EAST SUSSEX EVENTS

Death, Disaster, War and Weather

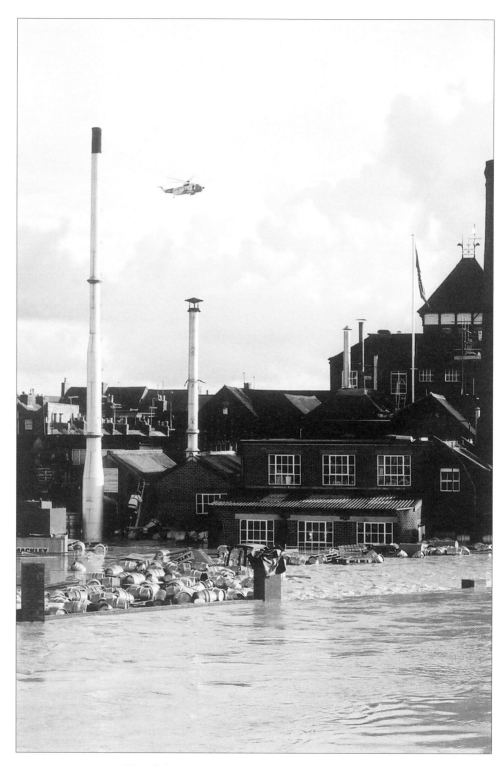

Harvey's Brewery under water in the Lewes flooding of 2000.

EAST SUSSEX EVENTS

Death, Disaster, War and Weather

David Arscott

Phillimore

2003

Published by
PHILLIMORE & CO. LTD
Shopwyke Manor Barn, Chichester, West Sussex, England

ISBN 1 86077 251 X

Printed and bound in Great Britain by
BUTLER & TANNER LTD
London and Frome

CONTENTS

LIST OF ILLUSTRATIONS

ACKNOWLEDGEMENTS

An author who is not himself a collector of photographs and postcards must needs go begging, and I am immensely grateful to the generous people who have come to my aid.

Chris Horlock, Dave Kibble and Gordon Clark have major collections on Brighton, Hastings and Eastbourne respectively, and I have thankfully drawn on these archives and on the holdings of the Sussex Archaeological Society in Lewes. Further material has been provided by Bob Armstrong, Mick Bird, Angela Darby, Betty Driver, Bill Gowin, Geoff Hutchinson, Richard Philcox, Des Puttick, Dave Rowland and Graham Vidler.

The *Argus* in Brighton has given me permission to reproduce recent photographs from their files, and several individual photographers have also kindly entrusted me with their work: my thanks to Doreen Ede, John Holloway, Janet Mortimer and Roger Saunders.

The copyright on old photographs is notoriously difficult to ascertain. I have given the source of the illustration in Roman type and the copyright holder, where known, in italics. I apologise for any omissions, which the publishers will be happy to rectify in future reprints: *Argus, 21-2, 25-6, 56-9, 124-5, 151-4, 168*; Bob Armstrong, 5; Mick Bird, 65; Gordon Clarke, 24, 35, 74, 97, 100-1, 111, 148; *Courier, 78*; Angela Darby, 129; Betty Driver/Stanmer Preservation Society, *127-8*; Doreen Ede, *10, 51, 55, 165*; Bill Gowin, 62; John Holloway, *17-19, 38, 52-4, 159-60*; Chris Horlock, 2, 4, 13, 27, *37*, 48-50, 64, 66-9, 73, 75, 81, 85-7, 90, 98-9, 103, 108-9, 112-13, 115-16, 118, 120-3, 135-9, 142, 149-50, 155, 158, 162-4, 166-7; Roz Horlock, *12*; David Kibble, 6-9, 29-33, 39-40, 42-6, 61, 63, 71-2, 76-7, 79, 91-4, 96, 130, 132, 140, 141, 146, *147*, 156-7; Janet Mortimer, *20*; Richard Philcox, 84; Des Puttick, *110*; RNLI, *36*; Dave Rowland, 102, 104-5, 117; Rye Town Council, *107*; Roger Saunders, *11*; Sussex Archaeological Society, *3, 14-16, 28, 34, 41, 47, 60, 70, 83, 89, 106, 126, 133-4, 143-5, 161*; Graham Vidler, 88; Waterloo Bonfire Society/David Quinn, *131*.

INTRODUCTION

Boasting proprietorial rights to the most famous date in English history, East Sussex is long overdue its own book of this kind. The difficulty for an author is making a selecton which holds a reasonable balance between the cheerful and the grim. That I have not entirely succeeded is due in part to the sheer volume of disasters and vicissitudes which have claimed the local – and sometimes the national – headlines over the centuries.

The county's geographical position has made it vulnerable to a variety of troubles. William of Normandy may have been the last successful invader, but many more have thought to follow him, as is testified by the impressive array of defences from different periods strung all our coastline. During the Second World War Sussex was in the frontline of aerial attack, and Eastbourne and Brighton in particular suffered severe bombing raids.

Storms are common enough throughout the realm, but maritime counties are necessarily more aware of the helplessness of ships in the face of the worst conditions. Literally hundreds of lost vessels lie under the sea off East Sussex, and several wrecks feature in these pages. On one occasion a seemingly unsinkable lifeboat was among the casualties, with the loss of all its brave crew.

The sea has also allowed smuggling, which was at one time so established it was estimated that a quarter of the tea consumed in Britain had arrived in the county illegally. There were many incidents involving 'free traders' and excise men, some of them ending in death. In terms of seriousness, smuggling is perhaps rather low in the crime scale, and certainly ranks below the worst of the murders recorded here. I have had no wish to overdo the gore, but it was impossible to leave out such horrors as the notorious Brighton trunk murders which for a time earned the town the soubriquet 'the Queen of Slaughtering Places'.

A surprise for those new to browsing through postcards created in their early 20th-century heyday is what the manufacturers saw fit to offer their customers. It would seem in the worst taste today to circulate pictures of

a fatal accident, although we do of course expect our newspapers, with proper restraint, to provide just such a service. (Images of the IRA bombing of the *Grand Hotel* in Brighton would certainly have sold like the proverbial hot cakes.) The upshot is that we have a fascinating, but random, record of events. Some of the incidents recorded here, such as fires and explosions, are unimportant historically, however dreadful for those caught up in them, but the dramatic nature of the photographs taken at the time gives them continued currency.

There have, of course, been happy occasions too (celebrations, royal visits, grand openings and the like), and many of them are featured here. I have also found room for one-off events, ranging from the creation of a new town to the physical moving of a complete lighthouse, my biggest regret being how much I have had to leave out. I had planned, for instance, to include a section featuring the strange displays put on by seaside entertainers in days gone by. Alas, those photographs, along with many more, must await another occasion, another volume – another event.

David Arscott
Lewes, July 2003

One
WEATHER

In a technological age we may sometimes persuade ourselves that we are in control of our environment, but storms, floods and other visitations of 'weather' have reminded successive generations of the forces we cannot possibly suppress. In East Sussex the fate of the two Winchelseas serves as the best reminder of our impotence. Back in the 13th century what we now call Old Winchelsea was a major port sitting on a shingle spit somewhere in the region of the present Camber Sands at the very eastern end of the county. During this period the sea was making steady inroads on the land, and in 1236 the town petitioned the king for aid.

Several storms subsequently washed away the port's precarious foundations. In October 1250 Holinshed reported 'a great tempest of wind' which caused the sea to flow twice without ebbing, drowning churches and some 300 houses in the town. Two years later Matthew Paris gave an account of a similar devastation, which 'drove ships from their anchorages, raised roofs of houses, many of which were thrown down, uprooted completely the largest trees, deprived churches of their spires, made the lead to move, and did other great damage by land, and still greater by sea, and especially at the port of Winchelsea which is of such use to England and above all to the inhabitants of London'.

In 1282, when it was almost too late, a royal commission recommended that the town be rebuilt on higher ground, and in July 1288 Bishop John de Kirkby blessed the land at Iham on which the new port of Winchelsea was already taking shape – and where it stands today. There had been another 'act of God' in the meantime: a ferocious storm on 4 February 1287 which changed the course of the River Rother and totally destroyed the largely abandoned town, washing its remnants out to sea. The only evidence of it today are the Alard tombs in the parish church, rescued from the former site before it disappeared.

The elements had a further trick in store for Winchelsea, however. The proud new port was laid out on a grid pattern, the only British example from

1 *The Strand Gate at Winchelsea, relic of a medieval town ruined by the retreating sea.*

this period of a planned medieval town, and it began to rebuild its earlier prosperity. Yet within a few generations the sea began to retreat all along the Sussex coast, leaving its ports shallow and silted. No port can thrive without relatively deep water, and Winchelsea's economy shrivelled, along with that of Rye and Seaford. Kipling, in his poem 'Sussex', writes of 'our ports of stranded pride'.

Several storms have been of such a magnitude as to become part of the historical record. On 26 November 1703, for example, it was said that the coastal sea-spray was driven so far inland that sheep declined to feed on the grass over an area of many miles; somewhat fancifully, no doubt, the village of Saltdean is said to have been given its name ('the salt valley') at this time. A tempest striking the Sussex coast two years later destroyed more than 130 houses in Brighton alone.

A dreadful blizzard in January 1726 brought an unexpected visitor to Rye. George I was at sea when the storm blew up, and his ship promptly sought the safety of Rye bay. The mayor, James Lamb, invited the monarch to stay during several days of heavy and impassable snowfalls – during which period his wife gave birth to a baby boy. The King stood as godfather in the parish church and the infant was, of course, christened George.

The early 18th century seems to have been a particularly tempestuous time. A tornado hit the East Sussex coast in May 1729, travelling inland at about 36 miles an hour. Houses and barns were flattened, thousands of trees

were uprooted, including some 1,400 on the Battle Abbey estate. The map-maker Richard Budgen wrote that at Sedlescombe, where many houses lost their roofs, 'a man in bed slept out the storm and knew not the conveniency he had for stargazing till awakened by the rest of the family'.

Occasionally we know of a storm simply because someone of note wrote about it. In November 1837 Charles Dickens was staying at Brighton during a ferocious coastal storm, and he wrote to his friend John Forster that 'the fishermen had profitable employment in picking up shoals of hats blown about the town'. A more widely reported Brighton event was the terrible storm of 12 July 1850, which inundated the low-lying Pool Valley just off the seafront. This was only the most recent in a spate of floodings at what was the natural drainage point for the town's streams, and the place where the Wellesbourne river (now channelled underground) discharged into the sea. In November 1723 a large ship had been 'cast into the Poole', and there was flooding to a depth of seven feet in January 1795 after a rapid thaw.

Seaford and Hastings took the brunt of a particularly fierce storm in November 1875. The wind had been blowing hard for days, but on Sunday morning 14 November it intensified to something like hurricane force. Shortly before high tide the sea rose over the beach at Seaford and swirled into the

2 *A print showing Pool Valley under water in July 1850.*

town centre. In the face of great waves shouldering the streets, local people fled their homes. 'People were fain to save their lives,' one man wrote to a relative, 'and its force was so as to smash everything to little pieces. I was in my house. I groped my way through the water and was very near to being knocked down a trap in the cellar. The water came up to my chin.'

A local photographer, R.W. Wynter, reported that 'bathing machines, boats, tables, chairs, beds and miscellaneous items were floating about in all directions. Many curious incidents occurred. The wheel from a bathing machine was forced partly through a window in Marine Terrace. A haystack in Lyons Place was carried away by the tide and stranded half a mile distant. At the old Assembly Rooms a billiard table was washed away and, curious to relate, was found three or four days later washed ashore at Cuckmere.'

In Hastings, where it rained heavily for eight hours, the Priory stream overflowed into the town. As the sea rose, it too poured inland, rushing along George Street, West Street and Pelham Street, surrounding the *Queen's Hotel* and running down Station Road. A policeman on duty near the *York Hotel* for some reason refused to leave his post, although he was waist-deep in water.

The *Hastings and St Leonard's Chronicle* reported that it was 'sickening to enter house after house and see such heartbreaking scenes, especially those inhabited by the poorer people, whose life, at the best, is a struggle with poverty. Everything is damaged beyond the hope of future utility … It is not an exaggeration to say that 256 dwellings is the lowest computation which can be made of those who have suffered.'

It was the poorest people, too, who suffered in the worst avalanche ever to occur in England. This was at Lewes on Christmas Eve 1836, and (as so often with natural disasters) might have been avoided. The jauntily named *Snowdrop Inn* stands at the site today, at the end of South Street, close to the Cuilfail Tunnel. In those days the little cottages of Boulder's Row lay in the lee of the steep chalk cliff. It had been snowing for days, and a gale had created deep drifts, blocking the roads.

The *Sussex Weekly Advertiser* later relayed the chapter of events to its horrified readers.

> The violence of the gale had deposited a continuous ridge of snow along the brow of that abrupt and almost perpendicular height, which is based by South Street and the Eastbourne Road, where tons upon tons semed to hang in a delicately turned wreath as lightsome as a feather but which, in fact, bowed down by its own weight, threatened destruction to everything beneath.
>
> Considerable fears were entertained on Monday for the line of cottages known as Boulder's Row, and these apprehensions were not diminished when a considerable fall occurred at Mr Wille's timber yard which destroyed a sawing shed. Mr Wille

advised his neighbours to quit without delay, but they refused. At about a quarter past ten two men implored the inmates to lose not a moment if they wished to save their lives. The poor creatures appeared, however, to be bewildered and could not be prevailed upon to depart. One man endeavoured to drag two women out by force, but he was compelled to desist in order to save his own life.

3 *Oil painting of the Lewes Avalanche by Thomas Henwood.*

What happened next was described by one witness as 'a scene of the most awful grandeur'. A great mass of snow cascaded on to the houses, breaking over them and dashing them onto the road. 'The scene which ensued was heart-rending,' the newspaper reported.

Children were screaming for their parents, and women were rushing through the streets with frantic gestures in search of their offspring; while in the midst of all this consternation men were hastening from all quarters for the purpose of extricating the sufferers.

Six people were rescued, including a child sheltered by its dead mother's body, but 15 were killed. There is a commemorative tablet to them in South Malling church, where they were buried.

Snowfall has become a rare occurrence, but there are several records of dramatic blizzards in days gone by. The one in January 1881 affected the

4 *The scene in London Road, Withdean, during the great blizzard of January 1881.*

whole county, burying roads, imprisoning people in their homes and freezing lakes (to the joy of skaters able to reach them). Shrieking winds drove the snow into large drifts. Nearly all the shops closed in Brighton, and the train from London became stuck in a fall at Lewes.

This great white-out was matched by another on 28 December 1908 when, the *Brighton Evening Argus* reported, 'those who have been hungering for an old-fashioned Christmastide found their wishes gratified'. Snow had fallen so heavily throughout the county 'that probably by the end of the day everyone will have had more than enough to satisfy their longing for real winter weather'.

By five o'clock in the evening the snow was lying to the depth of a foot. Buses were taken off the road in Eastbourne after one got into trouble at Meads Hill, and the trams came to a halt in Hastings. The *Brighton Herald* reported that a man had been found in Islingword Road, having made a couch in the snow: 'Here he was found insensible, though not from the cold. He was removed to the cells and had to answer next morning to the magistrates. He was lucky, for he would have slept the sleep of death.' A tragic outcome of the blizzard was the death of two men from Frant, who drowned when they fell through thawing ice at Eridge.

5 *Clearing up in Seaside, Eastbourne after the blizzard of 1908.*

6 *Fred Judge's photograph of the lightning at Hastings. It sold in huge quantities, and was at the centre of a row between rival postcard manufacturers.*

By this time the postcard craze was in full spate, and at Hastings there was a no-holds-barred rivalry between two local manufacturers, Judges and Angus Croyle. It came to a head when both firms produced photographs of a dramatic lightning storm over the town on 6 June 1904. Postcard dealers today are well aware that pictures were often doctored, otherwise identical scenes having waves, clouds, balloons and so on added to them. In this case accusations flew between the two sides over a period of two months, with rival advertisements being placed in the local weekly paper, the *Hastings and St Leonards Observer*.

In the 11 June issue Judges claimed to have sold more than 2,000 copies in three days and threatened legal proceedings unless the sale of pirate copies stopped. In the same issue Croyle claimed that he was the originator of the lightning postcards, using the slogan 'Legal opinion – others not to be compared'. The following week Croyle boasted sales of more than 7,500, and on 16 July – clearly stung by his rival's allegations – he offered £100 reward to anyone who could prove that his cards were not genuine. Judges, reporting steadily increasing sales, posted a figure of above 13,000 in seven weeks. Croyle then produced another lightning postard – 'the most wonderful ever produced'.

7 *The great hole which opened up in the promenade at Hastings after the storm of 1 November 1905.*

Whoever won the short-term battle, it should be noted that Judges (whose lightning cards are much easier to find than Croyle's) went on to become one of the country's leading mass producers of postcards.

A fierce storm in November 1905 produced a good crop of Hastings postcards, three of which are reproduced here. The most frightening out-come for local residents was the huge hole which opened up in the promenade after a severe battering from mountainous waves. It was a full nine feet deep and full of sea water.

The weather can, of course, be threatening without blowing up a storm. The 2nd August 1626 was declared a public day of fasting throughout the realm because persistent cold and wet conditions prompted fears of famine. The vicar of Mayfield reported what happened next in his diary: 'It pleased the Lord in great mercy the very same day to send a comfortable sunshine, and, after that, very seasonable and faire harvest weather, the like whereof hath seldom been with so little intermission or mixture of raine; herein verifying his promise – Psalm 50 – Thou shalt call upon mee in the time of trouble and I will deliver thee.'

A great drought dessicated the countryside in 1893. It began on 17 March and only a few drops of rain fell during the next 60 days. Eastbourne recorded

8 *The kiosk on Hastings pier was flattened by the 1905 gale.*

9 *Storm damage by St Mary in the Castle church, Hastings, 1905. 'I was sitting an hour in this shelter last Sunday morning,' wrote the sender of this card, 'reading Lloyds and watching the rough sea. It was swept clean away in the night.'*

10 *Beach huts smashed to matchwood by the 'hurricane' at Bexhill. How a few survived is a mystery.*

just 1.8 inches (30mm) of rain between 28 February and 3 July. On the positive side, crowds flocked to the seaside, and there was a splendid early display of wild flowers; on the negative, there were some huge forest fires and wells ran dry throughout the county – although two springs at Crowborough lived up to their reputation for being inexhaustible. Two years later there was yet another drought: between 28 April and 17 July a mere 0.68 inches (17mm) of rain was recorded at Crowborough.

Atmospheric oddities occasionally feature in the historic record, an aerial equivalent of today's crop circle mysteries. On 21 July 1662, for instance, many people at Burwash claimed to have seen a vision. They saw what appeared to be a great army in the northern sky, advancing from the direction of Brightling. Another army then approached from the south and engaged it in combat. After some time the southern army was completely routed.

At Hastings on 26 July 1797, hundreds of people witnessed a phenomenon recorded by William Latham in the *Philosophic Transactions*, the most respected journal of its day:

> I immediately went down to the shore, and was surprised to find that, even without the assistance of a telescope, I could very plainly see the cliffs of the opposite coast, which, at the nearest part, are between forty and fifty miles distant … Sailors and fishermen pointed out, and named to me, the different places they had been accustomed to visit. I could at once see Dungeness, Dover Cliffs and the French coast, all along from Calais, Boulogne etc to St Vallery, and as far to the westward as Dieppe. By the telescope the French fishing boats were plainly to be seen at anchor.

Another strange effect, although not an inexplicable one, occurred at Hastings on 6 March 1947. It is known as the 'amel', from the old English word for enamel. Rain froze as it fell, encasing everything, down to the last blade of grass, in a sheath of transparent ice: large boughs snapped from trees under the weight. Under the following day's sunshine, there was a brief dazzling kaleidoscope of reflections from a million glassy surfaces.

11 *Calm after the storm. Robin Court in Cooden Drive, Bexhill, was one of hundreds of buildings to lose its roof.*

The violence of the elements is, of course, no distant memory for those of us who have lived in East Sussex during the past two decades. The great storm of 16 October 1987 may not technically have been a hurricane, but that is how it is known to all who suffered its awe-inspiring venom. It had already been preceded earlier in the year, first, by a blizzard in January and then by heavy October rain, which not only brought widespread flooding but was responsible for a dramatic mudslide at Rottingdean – a full 28 acres of soil washing down from newly drilled farm fields into the High Street.

With winds of more than 100 mph recorded, the 'hurricane' wrecked buildings, destroyed literally millions of trees, brought down power lines, plunging most of the county into darkness, and claimed several lives throughout Sussex. Two of the fatalities were at Hastings. A four-ton chimney at the *Queen's Hotel* crashed down through four storeys, and Ronald Davies was crushed beneath the bricks and mortar. On the beach, helping to drag fishermen's boats ashore, Jimmy Read was hit by the roof of a winch hut.

12 *The Royal Pavilion at Brighton, undergoing restoration at the time, largely escaped damage, although a dislodged minaret crashed through the roof of the recently restored Music Room.*

Flimsy buildings stood little chance of survival if they found themselves in the teeth of the wind: the Rushy Hill caravan site at Peacehaven was smashed to smithereens, some 200 pyjama-clad residents running for their lives, and Jill windmill (on the Downs above Clayton) caught fire as her sails spun wildly in the tempest. Exposed church towers were horribly vulnerable: the 65-foot singled spire at

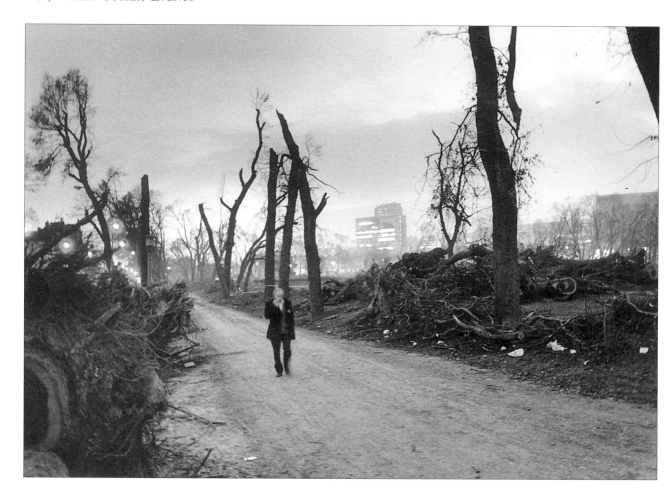

13 *The scene of devastation at the Level, Brighton, after the great storm. The area lost more than 300 trees.*

Rotherfield collapsed, while the spire of St Luke's United Reformed Church at St Leonards was deposited intact in a side aisle of the battered church. Handsome historic trees fell in huge numbers: at Sheffield Park large swathes were bludgeoned through a landscape partly created by Capability Brown.

The *Argus*, producing an evocative pictorial record of the event soon afterwards, declared: 'Many believe that Sussex will never be the same after those awful hours early on Friday 16 October, but they are under-estimating the resilience of Sussex people. A beautiful, green county WILL re-emerge from the havoc, and when it does this special issue will remind us how it was on the night the hurricane came.'

Recovery was, indeed, remarkably swift – rather more swift than that experienced by some victims of the floods which struck the county three years later. As our photographs show, flooding is nothing new in this area. The blizzards mentioned above always held danger once the snows melted: after the 1726 snows the wooden bridge over the Ouse at Cliff was washed

14 *Harveys Brewery in flood at Lewes, 1909.*

15 *Flooding at Landport, seen from Lewes castle* c. *1881.*

16 *Floods at Lewes, 1960.*

away, and there was flooding, too, after the 1881 storm. If there has been more bitterness about recent flooding, this derives from the feeling that it has been caused in part by human agency. Building on flood plains and embanking rivers, the argument runs, channels the rising water towards vulnerable areas downstream, with Lewes and Uckfield bearing the brunt of the brimming Ouse and Uck respectively.

It was on 12 October 2000, following days of incessant heavy rain, that the Ouse began to rise inexorably above its banks. By the early afternoon, as high tide approached, crowds were gathering on the Phoenix Causeway, scarcely able to believe the width and power of the river as it swept past the Tesco building into the narrow waterway alongside Harvey's Brewery and under Cliffe Bridge.

'It looked touch and go,' local MP Norman Baker wrote later.

> And then so much more water arrived so quickly. It overcame walls, rushed through gaps, and in minutes rather than hours the centre of the town was under water. I remember seeing the cars in the Safeway car park, which had been moved round to

the bus station side for protection, and which soon were trapped up to their roofs in water. All of Cliffe was under water bar the tiniest section of road at the top of the bridge. Eventually the water even lapped School Hill.

The damage was extensive. Several people were rescued from the rising waters, and literally hundreds of families had to leave their homes: some had not returned a year later to houses still drying out and subject to insurance claims. Shops, likewise, were inundated, their stock utterly ruined.

At nearby Barcombe, 36-year-old Julia Black was rescued by tractor and lifeboat before going into labour. She gave birth to an 8lb 3oz baby boy at Crowborough Hospital – fittingly, in a water tank.

17 *A lowering sky above the Tesco supermarket in October 2000 as the swollen Ouse rises to the riverside path.*

18 *Looking south from the Phoenix causeway towards Harvey's Brewery, which was swamped by the rising waters. The brewery later named the brew fermented this day Ouse Booze, and sold it to raise money for the flood appeal.*

19 *An elderly lady awaits rescue, her neighbours' cars almost totally submerged.*

20 *They shall not pass: the view down the Malling flyover, behind Tesco.*

21 *An aerial view of a swamped Uckfield.*

22 *Crowds venture as far as they dare down the slope of Uckfield High Street.*

For the people of Uckfield this was the third time in a year that the Uck had burst its banks. Six inches of rainfall in the space of 12 hours was to make this incident by far the worst, and much of the town was quickly six feet under water. Overflowing sewers posed an immediate health hazard, and a thick layer of silt and debris was left behind as the waters eventually receded.

One of the saddest victims of the weather in recent years has been the once-magnificent West Pier, although its demise once again reminds us of the vulnerability of our piers throughout history – to fire as well as storm, as we shall see. Brighton's first, the Chain Pier, had been completed in 1823 as a glorified promenade-cum-landing stage, and it proved to be a great survivor: its toll-house was swept away during a storm in 1824, it suffered a serious fire after being struck by lightning in 1833 and another storm in November 1836 damaged one of its bridges, yet it was still there when the West Pier was built in 1866. Alas, in November 1896 there was another vicious storm. This one destroyed the Chain Pier beyond repair, its wreckage slamming into the West Pier and causing damage amounting to £6,000 – a large amount at the time.

The *Brighton Gazette* reported that only a few timbers of the pile nearest the shore remained of the Chain Pier.

> A heavy sea was running all day and as the tide rose in the evening the waves dashed with great fury gainst the already injured structure. At ten to eleven, a few minutes before the tide reached its highest, the famous landmark broke up with a series of reports which sounded, in the fury of the wind and the waves, not much louder than pistol shots.

23 *The West Pier in 1896 after being damaged by wreckage from the old Chain Pier.*

On New Year's Day 1877 it was the turn of Eastbourne Pier, then only five years old, to face what the elements decided to throw at it. The weather was certainly bad, but not sufficiently threatening to prevent some of the locals taking a strenuous walk on it. The wind strengthened, however, and the waves grew. 'The waters rose up like an enormous wall,' the *Eastbourne Herald* reported,

looking fearful in their power, and descended with a blow which can only be compared to Vulcan's hammer. The pier began to stagger and violently oscillate and it became evident that it had completely broken in the centre. The excitement was now intense, as the first half, which was the weakest and received the greatest fury of the waves, gradually sank over to the east.

24 *Eastbourne Pier, wrecked by a storm in 1877.*

Men on the pier scrambled to safety, grabbed by those standing at the entrance, as the landward end of the pier collapsed. When the storm died down, the wrecked portion could be seen lying flat on the sands, leaving the rest as an island in the sea: it would eventually be rebuilt a little higher than the seaward section, as can be seen today. At this point,' continued the *Herald*,

25 *Further collapse of Brighton's West Pier in January 2003. Conservationists still hope to restore it by 2005.*

a foolhardy man named Hatton nearly lost his life through greed of gain. He kept rushing into the sea to pick up pieces of lead pipe, but on one occasion he was tumbled over by the waves and washed out to sea. Gallant fellows risked their lives to save him.

The gradual decline of Brighton's West Pier owes as much to neglect as to the elements, although – until the devastating fire of 28 March 2003 – every storm threatened to tip more of it into the sea. Amazingly, it survived the 1987 hurricane, chiefly because the worst of that storm didn't coincide with high tide, but early in 2003 the end was in sight. The *Argus* picture here captures the slide of the ballroom into the waves after a medium-sized storm in January. It's a sad picture, and one of the last before the flames did their work.

Our final 'weather' event is a tranquil one, the solar eclipse of 11 August 1999. I experienced it in a garden at Newick. The sky

26 *Scavengers were quickly on the scene to claim mementoes of the pier.*

27 *Crowds sitting tranquilly on the beach by the Palace Pier for the solar eclipse of August 11, 1999.*

darkened, although not completely, and a hush fell; all the birds in the surrounding pines stopped singing. It meant nothing and yet it was an unforgettable experience – an event.

VILLANELLE FOR THE WEST PIER

The lesson like the weather's pretty rough
As scavengers snatch driftwood from the tide:
We cared for her, but didn't care enough.

Eugenius fashioned her from sturdy stuff
But never dreamed we'd simply turn aside.
The lesson like the weather's pretty rough.

Parasolled ladies, bathers in the buff
Have posed upon, beneath her in their pride.
We cared for her, but didn't care enough.

From owners meanly calling Brighton's bluff
To ignoble neighbours' sneerings, cold and snide,
The lesson like the weather's pretty rough.

While earnest conservationists huff and puff
The dear old lady's practically died.
We cared for her, but didn't care enough.

Today her girders rust, her timbers slough
Away – oh, Lord with her abide!
The lesson like the weather's pretty rough:
We cared for her, but didn't care enough.

Two

SHIPWRECKS

Hundreds of ships have foundered off East Sussex over the centuries, and the wrecks of a great many of them are known to divers. Tales of bravery abound, but what happened after the *Nympha Americana* was washed ashore at Birling Gap on 29 November 1747 stands as a sorry reminder of human rapacity. The temptation, it has to be said, was great. The 800-ton ship, carrying up to 60 guns, had been captured from the Spanish off Cadiz by Commodore George Walker, captain of the *Royal Privateer*, who was bringing his prize to London with a rich cargo of quicksilver, velvets, clothes and gold and silver lace. As she got into trouble in heavy winds and snowstorms off the Sussex coast word quickly spread, and her arrival on the storm-swept beach was greeted by literally hundreds of people whose aim was not rescue, but plunder. One local group was known as the Seaford Shags, named after the marauding sea birds: 'God protect us,' ran an old seamen's prayer, 'from the Seaford Shags.'

Many of the scavengers were poor, and others were smugglers, accustomed to regarding any tax-free goods as fair game, with their pack-horses at the ready. They might also have argued, should they have felt it necessary, that these were already stolen goods. The fact remains that when the *Nympha* crashed against the cliffs the lives of her crew were in danger, yet nobody seems to have spared a thought for them.

The *Sussex Advertiser* later reported the incident and its aftermath in detail. Large casks of brandy were tossed onto the beach, and some were broken open by people who drank themselves insensible and perished of cold in the snow. As many as sixty looters are thought to have died from exposure.

'On the snow-covered beach,' Johnnie Johnson has written, in his book *Sussex Disasters*,

> those who had not climbed aboard stripped the corpses of the drowned sailors, or tugged necklaces from the throats of the weak, or ripped from their pockets what paltry possessions they had managed to save. A dead mother and her two small

daughters – were they passengers or wreckers? – all three were ignored in the melée. There were other tasks for the crowds. All kinds of booty which was coming ashore, either thrust in by the towering waves or lowered by ropes from the boat, had to be manhandled, carried off, loaded on the backs of horses, stowed in waiting wagons.

Troopers were called out to control the crowd, two of whom were shot dead, but some yielded to temptation themselves. Three soldiers were whipped at Lewes, charged with having seized goods they wrongly assumed had been taken from the wreck, while another was given 50 lashes for going absent without leave with a large haul of contraband.

One man who profited from the wreck, although legally, was the Lewes watchmaker Thomas Harben. After a salvage operation had been completed he bought up huge quantities of quicksilver at base metal prices. With the profit he bought a large house at Wellingham, near Ringmer, which he had dismantled and carted to Seaford, where, overlooking the sea, it is now known as Corsica Hall.

Little more than a year later another fine ship ran ashore in East Sussex, and the wreck is still visible at low tide close to the shoreline. The Dutch East Indiaman *Amsterdam* was on her maiden voyage to Java with a cargo of silver, wine and cloth when, on 26 January 1749, she ran aground at Bulverhithe, near Hastings. It seems that, unhappy with the captain's decision to sail on despite losing their rudder during a severe gale, the crew mutinied. In the brief two weeks of the voyage, fifty of the crew had died from an unknown disease, and another forty were sick and dying. Once they had taken over the vessel, the desperate crew broke into the cargo of wine to drown their sorrows – a literal case of Dutch courage. A watcher on the shore apparently heard their drunken shouting as the boat beached, a report given credence when archaeologists discovered that poorly corked wine bottles on the lower gun deck had been opened before the ship was wrecked.

It seems that the Shags were at it again, since we find the Mayor of Hastings, William Thorpe, writing that 'this happening so soon after the *Nympha* has destroyed the morals and honesty of too many of our countrymen for the very people hired to save did little but steal.' Many of the artefacts from the *Amsterdam* are now in the Shipwreck Heritage Centre at Hastings, which has included a report on the wreck in one of its booklets:

> Among the other discoveries on that deck are some human bones which have been firmly identified as belonging to Adrian Welgevaren, a boy from the small Dutch market town of Leerdam. Ironically, he probably died on 26 January, which was his fifteenth birthday. Although disease may have killed him, it seems that as he was probably Captain Klump's cabin-boy he may have been shot during the mutiny.

A wrecking more notable for its heroic rescue attempt than for what happened on board or to the cargo occurred off Newhaven on

26 January 1800. The warship HMS *Brazen* appeared off the coast with most of its 106 crew already drowned, but others were clinging to the rigging or were in the sea, clutching improvised liferafts. On top of the cliffs the Royal Humane Society had installed their so-called 'life-saving engines' – large cages suspended from two swinging cranes. The problem was that the sailors had to reach the foot of the cliff before they could clamber into them, and several of them perished when close to the shore. The brave civilian cranesmen wheeled their engine along the very edge of

28 *Wreck of the Gannet at Seaford, February 1882. She was to break amidships in another gale, her keel visible at very low tides for many years. Her propellor shaft is exhibited on the seafront.*

the cliff and let a cage down with two of their colleagues inside. With great difficulty the men grabbed a half-conscious sailor who had been clinging to a gunslide as he drew close to the foot of the cliffs, hauling him into the cage. This was Jeremiah Hill, a non-swimmer and the only survivor. A subscription was raised in Brighton to reward the cagemen, and an imposing monument to the drowned sailors was erected in the churchyard at Newhaven.

Some two miles west of Beachy Head are the remains of the wool clipper *Coonatto*, on her way from Australia to London in 1876 with a cargo of copper ingots and wool when she was driven ashore at Crowlink. This is a wreck prized by historians at the Shipwreck Heritage Centre because she was built at a time when the hull construction of large ships was being changed from wood to iron, and when engine power was taking over from wind power: 'The *Coonatto* was both iron-framed and timber-framed, as her remains show, but she was still powered by sail.'

When the SS *Gannet* ran aground in Seaford Bay on 14 February 1882, the crew were saved by rocket apparatus and put up at the *Bay Hotel* in Pelham Road. (A young woman working there helped an officer dry the ship's papers and ended up marrying and returning with him to India.) Carrying a mixed cargo of tea, coffee, wheat, rice, cotto, indigo, linseed, hides and horns, the ship was on her way to London from Calcutta when she came ashore in fog. A bridge was improvised from the ship to the sea-wall, with a double track for wagons. The cargo was then unloaded by block and tackle, some of it being carted to the railway station for immediate transfer to London and the rest stored in a barn at Pigeon House Farm. 'In spite of these precautions,' local historian Patricia Berry has written, 'there was no demand for tea or coffee from the town's grocers for some time!'

Another celebrated wreck at Seaford was the Danish iron barque *Peruvian* on 8 February 1899. She was carrying a cargo of corona nuts, imported for the manufacture of buttons. Many were washed up on the beach, and were painted with shipwreck and other scenes. Some examples can be seen at Seaford Museum, which has other relics, including a restored figurehead and and one of the two timber and metal arms ('cat-heads') used to draw up the forward anchors.

The postcard manufacturers were assiduous in snapping any vessel in trouble off the coast. The stories behind some of them have now faded, but the story of the German steamship *Lugano* is well documented. She was on her way from Baltimore to Hamburg with a cargo which included cotton, timber and oil, when the cotton self-ignited. She was towed by a tug to a spot

29 *Wreck of the* SS Clara *off Hastings, June 1905.*

five miles off Hastings, but flames were later seen coming from the ship. The Hastings lifeboat *Charles Arkcoll II* was launched – this was her first major mission – and went alongside. The fire being out of control, the *Lugano* was now towed close inshore, where she dropped anchor.

Steve Peak has recounted the next day's events in his book *Fishermen of Hastings*: 'Large crowds gathered to watch the dramatic spectacle of an ocean-going ship burning only a few hundred yards from Hastings seafront. Later that day the vessel was towed to the east side of the harbour, where she lay on fire for more than two days. The *Charles Arkcoll II* stood by and rendered assistance while the fire was gradually extinguished.'

30 *The Hastings lifeboat* Charles Arkcoll II *alongside the* SS Lugano *off Hastings.*

One of her crew later recalled: 'We lay alongside for 48 hours. The decks got too hot to walk on and her sides were red hot.' On May 3 lighters began taking off the remains of the *Lugano*'s cargo, and on May 5 the smoke-blackened vessel was towed to Tilbury. Luckily the whole episode took place in fine weather, turning what could have been a major disaster into a unique free show for Hastings and its visitors – and allowing the *Charles Arkcoll II* to display favourably its capabilities to huge crowds.

The lifeboat was launched 25 times between 1901 and 1931, saving 28 lives. This was despite a real launching difficulty, which had been partly responsible for the first *Charles Arkcoll* failing to save a single life in her 20 years of service. The lifeboat house was situated on the eastern foreshore, whereas the best place for a launch was at Bo Peep, well to the west. *Charles Arkcoll II*'s first live-saving launch in 1906 was achieved from the harbour, but when the London sailing barge *Amy* got into trouble on 25 April 1908, it was clear to the lifeboatmen that they must launch from Bo Peep. The locals had seen the exercise before, and probably by now almost took the spectacle for granted, but it does seem an oddity that the lifeboat should need to be hauled by horses a couple of miles along the street through St Leonards.

This was a particularly difficult rescue. The *Amy* had struggled around Beachy Head in a westerly gale, but when her topmast and bowsprit were damaged she turned back towards St Leonards, dropping her anchor close inshore. No distress signals had been seen – it transpired that the crew had

found nothing with which to hoist a flag – but observing that the gale had snapped the barge's anchor cable, the lifeboat coxwain, Jack Plummer, decided to launch the lifeboat.

Thousands of spectators watched the *Charles Arkcoll II* make for the drifting *Amy* in a thickening blizzard. Boarding her, lifeboatmen found the skipper and his two crew in an exhausted state, and decided they must take her to shelter on the east side of Dungeness. Suffering for hours in the wet and cold, they brought the *Amy* and her crew to safety.

32 *Lifeboat being drawn through St Leonards on her way to a launch at Bo Peep, April 1908.*

33 *The launch in heavy snow.*

Mention the year 1912 in connection with accidents at sea and the word *Titanic* comes immediately to mind. There is, indeed, an East Sussex connection with that disaster, since one of the bandsmen on the Titanic was an Eastbourne man: John Wesley Woodward was a cellist with several local orchestras, and a plaque on the lower promenade opposite the bandstand (unveiled in 1914 by Dame Clara Butt) tells us that he perished 'with others of the hero-musicians'.

34 *Wreck of the* Khokand.

Eastbourne had its own drama in the same year, however. The P&O liner *Oceana* collided with the barge *Pisagua* off Beachy Head, and several of the crew lost their lives. *The James Stevens no.6* lifeboat saved twenty passengers, while another twenty and most of the two hundred crew were rescued too. Salvage teams recovered a large amount of gold and silver bullion.

Lifeboats are generally regarded as unsinkable, but the story of one that capsized with the loss of all its crew is surely the most appalling single event recorded in these pages. The boat was the *Mary Stanford*, and she was based at Rye Harbour, the epitome of that cliché, a small closely-knit community. Almost every family earned its living from the sea, and everyone there either knew or was related to the 17 men who were called to man the boat in the early hours of 15 November 1928.

Most were experienced lifeboatmen. In her 12 years at Rye, the *Mary Stanford* had been launched 16 times on active service and had saved ten lives from the dangerous waters of Rye Bay. Her crew had an average age of 29 years – Alex Pope was the youngest at 21 and would be in the crew for the very first time; Herbert Head the oldest at 47. All were friends, a number were related and several had families. It was at 4.50 a.m. that Rye Harbour Coastguard Station took the message that the Latvian steamer the *Alice of Riga* had collided with the German steamer *Smyrna*. A hole torn in her side, and her rudder gone, she was drifting, with a cargo of bricks, some three miles south-west of Dungeness. The maroon sounded just after five o'clock.

The weather was dreadful. A south-westerly gale of up to 80 mph had been blowing for hours, carrying spray four miles inland. Visibility was down to a few yards. The men responded swiftly – 'as if they had slept with their clothes on' commented the vicar afterwards – and sprinted the mile and a half to the lifeboat house in the pitch dark and pouring rain. They were joined on the beach by the team of launchers who helped get the *Mary Stanford* away. It required a superhuman effort, the boat pulled across the beach on heavily greased skids, the men up to their shoulders in the sea as they attempted to float her. At around 6.45, on the third attempt, they succeeded, and the crew began setting the boat's sail and rowing through a mountainous sea. They were exhausted before their work had begun.

Minutes after they were on their way the coastguards received the news that the crew of the *Alice* had been rescued by the *Smyrna*; the lifeboat wasn't needed after all. Now the signalman fired the recall signal, and men dashed into the surf with loudhailers in an attempt to stop the *Mary Stanford*. Unable to catch the crew's attention at his first attempt, the signalman tried again. It was too late. She had set out in fruitless search of the *Alice*, in conditions which worsened as the hours passed.

At 9 a.m. the lifeboat was seen by the SS *Halton*, three miles from Dungeness, in good order, with two small tug sails set. It was at about 10.30, coming home to Rye Harbour, that disaster struck. A little more than a mile

35 *The* Oceana *off Eastbourne, with the Newhaven–Dieppe steamer* Sussex *standing by in the foreground.*

36 *Flower-bedecked coffins at the funeral of the 17 crew of the* Mary Stanford.

from safety she overturned, engulfed by a huge wave. Her mast snapped and the crew were thrown into the turbulent waters. Over the hours that followed their bodies were washed up, one by one, on the shore.

At the subsequent inquest, questions were asked about the suitability of the men's life-jackets. The timing of the message standing the lifeboat down was also the subject of great debate. The terrible fact was, however, that 17 brave men had lost their lives unnecessarily, leaving 11 children fatherless and nearly every family in the village touched by the tragedy. The funeral, needless to say, was an impressive, sombre and moving occasion. A monument was later raised above the communal grave, bearing the inscription 'We have done that which was our duty to do'.

Subsequent dramas at sea have, mercifully, been less dramatic. Indeed, some incidents, however costly for the owners, have been spectator events, giving local people a close-up view of a range of vessels not usually brought so close to shore. Older readers in the Eastbourne area may recall the arrival of the Greek ship *Germania*, which had collided with the Panamanian steamer *Maro* off Beachy Head in fog in April 1955. She spent some time on the reef beyond Cow Gap and was eventually taken to Germany for repairs.

Certainly, thousands of Brightonians remember the Greek cargo ship *Athina B* running aground on the beach east of the Palace Pier in January 1980. She had sailed from the Azores for Shoreham with 3,000 tons of pumice, but failed to get into the harbour and began to drift eastwards in worsening weather. Most of the crew were rescued by the Shoreham lifeboat on the morning of 21 January but the captain and other crew members stayed aboard as she continued to drift; they were taken off shortly after nine o'clock that evening. The *Athina B* ran aground later that night, and remained as a tourist attraction for almost a month; Volk's Railway even ran an out-of-season service to provide a good view. Declared a write-off, its pumice off-loaded, the ship was at last hauled from the beach on 17 February, towed to Chatham and scrapped. Her anchor was installed as a memento on the promenade between the Aquarium and Peter Pan's Playground.

Another wonderful 'photo opportunity' was offered by the Dutch sail training ship *Eendracht* when she came ashore in gale-force winds at Tide Mills, just east of Newhaven, on the morning of 21 October 1998. She had a crew of 51 young sailors, all safely airlifted ashore by helicopter and no doubt rather enjoying the experience.

37 Athina B *beached off Madeira Drive, Brighton.*

38 *The Dutch training ship* Eendracht *on the beach at Tide Mills. She sailed away with little damage.*

The ship had spent the previous night in Newhaven harbour. She put out at eight in the morning but was at first stuck on a sandbank and then suffered engine failure before being washed up onto the shingle. Newhaven lifeboat and the local tug *Meeching* tried unavailingly to attach lines to her in order to pull her upright. Large crowds gathered to watch repeated attempts to free her until – on the afternoon of the third day, and after mechanical diggers had been brought in to clear shingle banked against her seaward side – she at last swung upright and was towed off by a Dutch tug. An eye-witness reported 'cheers and tears of joy from the watchers on the shore' as the handsome vessel set off on her way.

Three

FIRES

Most fires are accidents, but the blaze that wrecked a handsome and spacious mansion in St Leonards on 15 April 1913 was almost certainly the work of political activists – the Suffragettes. The evidence was strong. Levetleigh (in Dane Road) had, until a few weeks before, been the home of the borough's MP, Arthur du Cros, an outspoken opponent of the women's suffrage movement. The policy of the Women's Social and Political Union was to attack property rather than people, and a placard was found in the charred remains of the house reading 'To stop militancy, give votes to women'.

The arsonists were believed to have come to St Leonards by car, but this failed to prevent unlikely rumours that the culprit was the novelist Sheila Kaye Smith, then in her mid-twenties and not a suffragist. She later wrote about what must have been a very uncomfortable time:

> Rumour knocked me down and blacked my eyes. I did not mind, for I was not opposed to women's suffrage – just not interested (I should think better of myself now if then I had at least done a little to help win that nothing, which should have been so much). I did not really mind – though my family did – when I was accused of burning down Levetleigh, the borough member's house, which stood opposite ours.
>
> It was destroyed one night, almost certainly by suffragists, and I remember the bitter disappointment with which, on waking the next morning, I realised what a spectacle I had missed. I had never seen a fire, and this by all accounts had been a specially splendid and satisfactory one. I felt a little ashamed of having slept through it. Therefore great was my surprise when I heard that I myself had done the deed. The evidence was clear – I had sat at the window, mocking the efforts of the fire brigade and shouting 'Votes for Women!' The firemen themselves had seen me and had told the police.
>
> For a time things looked unpleasant, and might really have been so if my father had not succeeded in establishing my innocence, at least in official quarters. Nearer to indignation than I have ever seen him in my life, he visited the police station, he visited the headquarters of the fire brigade, he visited his club, where the scandal died last of all – if indeed it can be said to have died, for I believe that there are still people who think that I burned down Levetleigh. It it just the sort of thing a novelist would do.

Windmills were dangerous places to work in, and countless accidents occur in the historical record, from entanglements in moving machinery

39 *The Levetleigh fire, with the manion already a shell.*

40 *The gutted interior.*

to ghastly decapitations. Fire was an ever-present hazard, with sparks liable to fly from the millstones. Malling Mill, at the top of Lewes, had a particularly bad record, as was noted by the windmill historian H.E.S. Simmons. The *Sussex Weekly Advertiser* covered no fewer than four accidents in the early 19th century – although in one case it was the mill that came off worse when a 'swift' (that is, a cloth-covered sweep) struck a grazing cow. In 1803 the grinder suffered a fractured skull when the hoisting tackle fell on him, and in 1821 the grinder's brother was caught in the machinery and had to have his hand amputated.

The worst incident occurred on 3 January 1817: 'As a poor woman named Wood was returning home from the house of the miller of Malling, to shorten her passage she cut across an enclosed spot of ground on which the mill stands in

a direct line towards the swifts, one of which struck her on the arm and shattered the bone to pieces and before she could get out of the way the next met her and dreadfully fractured her collar bone and one of her thighs. She was conveyed home where she languished until Thursday and expired.'

A fire was just waiting to happen. It broke out on 8 September 1908, and there was little the fire brigade could do to save it. The post-mill stood 110ft above the River Ouse, and the steam-driven fire pump could only be employed to raise water from a small reservoir. The mill's roundhouse was later converted into a home.

We have observed the obvious threat to piers from the weather, but fire has proved a hazard, too – even if water, in this case, is very close to hand. Hastings Pier suffered a serious blaze on Sunday 11 July 1917, at a time when, thankfully, the public were barred from it: as a wartime precaution the pier had been breached to prevent it being used as a landing stage. The pavilion was completely destroyed and wasn't replaced until 1922. Eastbourne

41 *Malling Mill fire, Lewes, 1908.*

42 A dramatic scene as fire destroys the pavilion on Hastings Pier.

43 The charred remains. 'Thought this might interest you,' wrote the sender of this postcard chirpily in November 1917. 'It happened in July.'

Pier suffered similarly in 1970, on this occasion at the hands of an arsonist. Its pavilion has never been restored.

Neither could the abundance of local water save the *Bear Inn* at Lewes from a raging inferno on 18 June 1918. It stood on the banks of the Ouse at Cliffe (the site now occupied by Argos), and four fire brigades combined for all of five hours in an attempt to save it, with the Newhaven steam fire launch *Haulier* shooting great gouts of water from the river. The miracle was that the store next door (Rice's, selling saddlery, cycles and, more pertinently, petrol) managed to survive. It caught fire eight times, but on each occasion the firemen successfully doused the flames.

45 Tapner's Warehouse ablaze in Waterworks Road, Hastings, 4 January 1909. The postcard was tinted to give the effect of flames.

44 Sombre looking staff c.1908 after a fire affecting two Hastings businesses at West Hill Mews: J.H. Towner and B.H. Vidler.

A series of commercial and industrial fires during the Edwardian period which proved irresistible to postcard manufacturers.

46 A crowd gathers outside the Mastin Bros store, Hastings, in December 1904.

47 *The fire at Smith's, 170 High Street, Lewes in 1907.*

When the Grand Theatre burned down at Brighton in 1961, public sadness was for the loss of a fine old building rather than for an amenity: it had for some years been used as a furniture factory. It was originally opened in North Road as the Hippodrome Circus in 1891 by the entrepreneur Fred Ginnett, was converted into the Eden Theatre by Frank Matcham and became the Grand Theatre, the most popular in town, in 1904.

There was anger as well as sorrow when the handsome *Bedford Hotel* on Brighton seafront was wrecked by fire in 1964 with the loss of two lives. It had already been the subject of controversy. The council had debated plans to replace the hotel with a larger building, the visionary (but often purblind) Councillor Lewis Cohen stating: 'This is a hotel which is completely out of date.' Although only the roof and upper storeys were destroyed by the fire, the building was later demolished and replaced by an unloved modern block described by Anthony Seldon, in his book *Brave New City*, as 'one of the ugliest buildings in the city'.

48 *Two people died in the fire at the* Bedford Hotel.

49 *A firework may have begun the fire which destroyed the*
Johnson Bros store in Brighton.

Was a smouldering firework responsible for the devastating fire at
Johnson's furniture store in Western Road, Brighton, in 1970? The fire was
spotted by a patrolling policeman in the early hours of 6 November. It took
75 firemen from both East and West Sussex three hours to control it. The
building was damaged beyond repair but, in a heart-warming gesture, the
heads of other department stores in the town rallied round to help. The fire
was the beginning of the end, however. The store moved into temporary
premises elsewhere, but in 1979 it closed its door for ever.

One of the best-attended fire-fighting shows of recent times took place
on Brighton seafront in November 1998 after an unfortunate trainee hotel
chef cooking sausages for breakfast saw flames from his frying pan shoot up
an extraction flue to the roof. The *Royal Albion Hotel*, in a commanding
position close to the Palace Pier and the Aquarium, was well alight within
minutes. Some 160 firefighters tackled the blaze and managed to prevent
the complete destruction of the building. Although the guests were swiftly

50 *Grand Theatre*
fire, Brighton. The
building still had its
grace notes, despite being
used as a furniture
factory.

51 *A fire almost under control at the corner of Sackville Road and Western Road, Bexhill, 1986.*

52 *The* Royal Albion Hotel *ablaze in November 1998.*

53 *After the fire was over. The hotel was eventually completely restored.*

54 *A view from the Palace Pier, with firemen drawing water from the sea.*

evacuated, one couple contrived to sleep through the alarm and emerged hours later to discover how narrowly they had escaped.

An arsonist is thought to have started the fire at the former Charters Ancaster prep school building in Penland Road, Bexhill, in the early hours of 9 November 2001. The school had moved some years previously, and Bexhill College was in the process of buying the empty property at the time of the fire. The new college began to rise on the site during 2003. Since our photographer took this dramatic picture from her window, let's hope that her present view of the sea isn't obscured.

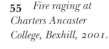

55 *Fire raging at Charters Ancaster College, Bexhill, 2001.*

We return to piers to conclude this chapter, first to the Palace Pier, which (in anticipation of the demise of the West Pier, no doubt) the owners now like to call Brighton Pier. Only weeks after the further collapse of its rival into the sea, the Palace Pier itself suffered what for a time seemed a devastating fire. It began in the ghost train on the evening of Tuesday 4 February 2003, and spread to amusements nearby, burning a hole through the decking. Dozens of staff and visitors were taken off the structure,

56 *The fire on the Palace Pier in February 2003, which began in the ghost train.*

57 *The badly damaged helter-skelter. The pier opened for business again the next day.*

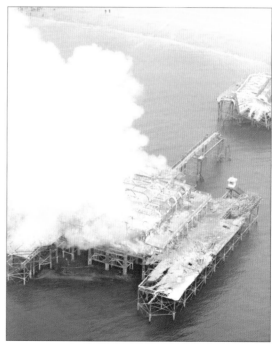

58 *It's 28 March 2003 and the Pavilion of the West Pier is ablaze. Police suspected an arsonist. Closer to the shore is the concert hall, destroyed earlier by storms.*

fortunately without injury or loss of life. Flames rose 30 feet into the evening sky, and watchers on the promenade began to imagine a future without either of its two piers.

The fire had been picked up by CCTV cameras, and seven crews were quickly on the scene, with the Brighton and Shoreham lifeboats standing by. Although the fire was under control within about three hours, a secondary outbreak was reported at 2.30 the following morning. Despite this, the pier was open for business again on the Wednesday, with only the funfair area out of bounds.

That seemed to be the end of a very bad few weeks for the town's piers – until, on 28 March, a devastating fire at the West Pier finished off what the waves had almost managed to do. It was a cruel and sickening end.

59 *The flames raged for three hours reducing the building to a blackened skeleton.*

Four

ACCIDENTS

On 26 June 1796 a Mrs Shepherd, who ran the *Red Lion* public house at Crowborough, was crossing her skittles alley where some men were playing when 'she was unhappily struck by the bowl on the temple', fracturing her skull. The *Sussex Weekly Advertiser* reported that 'she was soon after trepanned, but to no good effect, as she languished till Saturday, and died in the greatest agony.' That's bad luck in a nutshell. How many times must she have crossed that skittles alley before? How likely was it that someone should take so bad an aim? The historical record is littered with examples of random accidents such as this.

Not that all bolts from the blue are as inexplicable. To work in the Battle gunpowder industry in years gone by was perhaps to take more risk than Mrs Shepherd might have found acceptable. There were seven mills at Battle, and between 1764 and 1874 there were at least ten explosions with the loss of 18 lives. In 1764 four men were killed in a sifting house explosion, two of them being sons of the proprietor. An explosion in 1798 killed three men and destroyed seven industrial buildings and a house.

At Brede, a few miles distant, a powdermill explosion in March 1808 blew out all the windows in the parish and was heard 25 miles away in Lewes. Two workmen and a child died in this accident, and the *Advertiser* reported it in detail:

> One of the men, named Sinden, at work in the sifting house, had his head and limbs separated from his body and carried in different directions to a neighbouring wood wherein they were collected and placed together and presented a shocking spectacle. The other, named Harrod, it is supposed was killed crossing a small bridge with a barrel to deposit in the magazine, as his left shoulder and part of his head were blown off. The child was killed in an adjacent cottage that was much shattered by the explosion, either by the fall of the chimney or from the stroke of a piece of iron which came into contact with his bowels and tore them out; he nevertheless survived the injury a few hours.

Vicars were not always at their most sensitive when writing entries for the parish records. Sinden's death was recorded in the Salehurst burial register

as follows: 'Cause of death: blown into 5 parts, his head, his leg, thigh and arm, and other arm from sudden explosion of Brede Gunpowder Works.'

Strangely, the very last accident at Battle occurred after the mills had closed down: a glazing house was being dismantled at Peppering Eye when there was an explosion which left the carpenter responsible incapacitated for several weeks.

Butchering may be a considerably less dangerous occupation, but it was the undoing of 18-year-old Thomas Jeffery at Chailey. He died on 18 October 1852 and his tombstone, just inside the churchyard wall, tells us what happened: 'When pursuing his trade as a butcher his knife slipped and severed the main artery of his thigh, after which he lived only one hour. Thus suddenly in God's providence was this young communicant taken to his rest.'

One of the most dramatic accidents of the early 19th century saw the complete collapse of a vast, glass dome – indeed, the largest dome in the world at the time – which stood, all too briefly, in Palmeira Square in Hove. This was the Anthaeum, 160ft in diameter, 492ft in circumference and 64ft high. The dream of an eminent botanist, Henry Phillips, it had its interior laid out as a garden of tropical plants. The idea was that the Anthaeum would attract visitors all though the year, with winter furnaces stoking temperatures up to 90°. Phillips handed the job to the headstrong Henry English of the Griffin Foundry in Clerkenwell. He in turn chose the great Amon Henry Wilds as the architect. Work began at the end of July 1932, with a local builder, George Cheesman, setting to work on the deep foundations. Some 500 tons of ironwork was brought in by sea.

A major dispute now arose over the central pillar, around which there was to be a spiral stairway leading to a cupola and observation terrace. Wilds wanted it to be strengthened, but English didn't think it was necessary at all. The ribs, he argued, were made of cast iron and well supported. The two had such a violent disagreement that Wilds was forbidden to set foot on the premises again.

The building was to be opened to the public on 29 August 1833, with a grand official opening on Sunday 1 September. On the 28th Phillips arrived, to discover that the central pillar had been removed. This surprised him, but the open day nevertheless went ahead; thousands of people crowded into the Anthaeum, marvelling. A *Guardian* reporter, who wrote that 'the effect was particularly grand', thoughtfully pointed out to the foreman that some of the ribs at the top of the structure seemed to have developed a peculiar twist. At about seven o'clock that evening two workmen locking up for the night heard a cracking above them and, with an enviable instinct for

60 *Human error or sabotage was responsible for the fatal explosion at Lewes railway station in 1879.*

survival, dashed outside, clearing a fence and reaching safety just as the entire building crashed to the ground. The remains stayed there for 20 years, and the shape of the Anthaeum can still be seen when the grass is parched in a drought.

The worst kind of luck befell the victim of a sudden explosion in Queen's Road, Hastings, on 26 August 1906. Postcards were, of course, produced immediately. The one seen opposite was sent the following day, with the message: 'Hope you are all serene, as we are. Thought you would like a view of place of sad accident.' As the crudely scrawled legend explains, a stone cover was blown 20 feet in the air.

The railway came to Sussex in the 1840s, and with it the prospect of a new and terrible kind of accident. The worst of these occurred on 25 August 1861 in the Clayton tunnel, just inside West Sussex, and involved hundreds of day trippers on their way back to London from Brighton. Although the signalling system was designed to ensure that no train entered the tunnel until the way ahead was clear, a mechanical failure and a series of mistakes by staff allowed no fewer than three trains to crash. No help

SCENE OF EXPLOSION IN QUEEN'S
ONE PERSON KILLED.
X
STONE COVER BLOWN UP 20 FT.
SUNDAY EVENING AUG 26.06.

61 *Explosion in Queen's Road, Hastings, 1906.*

came for more than half an hour, and it was horribly inadequate. A total of 23 passengers died, and nearly 200 were injured.

Fortunately no later incident compared with this, although there have been shocks aplenty, and occasional deaths. In September 1879, for instance, there was an explosion at Lewes station after a Hastings–London passenger train had come to a halt there. The local newspaper reported that the engine took water while the driver went round with his oil can.

62 *A spot of bother at Etchingham in 1909, when a local goods train was derailed. Engine no. 268 was carrying barrels of butter and lard on the South East and Chatham Railway's Tonbridge–Hastings line. After heavy rain a culvert became blocked and ballast was washed out from under the rails. Nobody was hurt, and the line was reopened the following day.*

63 *Happy landings. A cloaked policeman passes among the crowd of onlookers after what appears to have been a near miss between these two buses in Havelock Road, Hastings, c.1910. The crashed vehicle carries an advertisement on its front for* The Geisha & the Greek Slave.

As Driver Rookwood received the 'right-away' and eased forward, the firebox blew up, showering the train and station with steam, boiling water, soot, coal and ballast. The engine was thrown off the rails, its smokebox door blown off, and Rookwood was found dead on the roof of the second carriage. His fireman and guard were injured but survived.

It was later discovered that the safety valves on the engine had been tampered with and set to blow off at a different setting from the norm.

Trams generally had a good safety record. Brighton had a system of just under ten miles, which ran for 38 years from 1901 with only two accidents. The first was in 1904, when a car ran out of control down the steep hill of Elm Grove, and four men managed to jump to their safety, escaping with only minor injuries. The second, more serious, incident occurred at seven o'clock on a blustery September morning in 1935 when the brakes failed on a no. 74 as it was negotiating the steep part of Ditchling Road just above the Level. It jumped the points at the junction with Union Road and overturned. A cyclist was hit by the tram and killed, and 24 people were injured.

Air crashes have been a regular occurrence over East Sussex, sometimes with loss of life. One of the strangest occurred at Eastbourne on 4 June 1955. The Royal Air Force Association was holding its silver jubilee conference in

the town, with guests including Prince Philip, the Duke of Norfolk and Lord Tedder (Marshal of the RAF), and a highlight of the occasion was the arrival of a Coastal Command Sunderland flying boat. Large crowds watched it circle slowly over the town, make a graceful descent and taxi along the surface. What happened next was never properly explained. At one moment the flying boat appeared to be comfortably settled on the water; the next its tail had shot up in the air and the aircraft was submerged in dense spray. RAF launches, the Eastbourne lifeboat *Beryl Tollemache* and the pleasure boat *William Allchorn* all rushed to help as men were seen scrambling onto the starboard wing. Ten out of the 14 on board were rescued, but four were drowned, including the pilot, Flight Lieutenant Gush, and the only Sussex crew member, Leading Aircraftsman J.K. Rothwell from Peacehaven.

64 *The scene of Brighton's only serious tram accident, near the Level.*

The wireless operator, Sergeant Geoffrey Bevis, told the inquest that all had seemed well as they came in to land, although he had warned the crew that the sea-swell might make the landing rough.

> Everyone relaxed, thinking that we had come down safely. Suddenly I was shaken all over the place. There was a juddering and a hammering, and then I was in the water. The plane's nose was up and I saw light and swam towards it and managed to crawl out on the wing.

TOP-SECRET JET 'BLITZES' HOMES

TILES torn from roofs, window frames ripped out, a railway line strewn with debris—picture right. This was the blitz-like scene after a top-secret Valiant jet-bomber crashed and exploded at Southwick, Sussex, yesterday. Flaming wreckage was flung more than a quarter of a mile. Women and children had miraculous escapes.

BLAZING BOMBER MISSES SCHOOLS

A £1,000,000 Valiant—one of Britain's newest jet bombers—skimmed the roofs of two schools yesterday and exploded as it crashed through gardens on to a railway line.

In the school playgrounds at Southwick, Sussex, hundreds of children were at play.

Mr. George Wade, caretaker at the primary school, said: "It came straight at us with smoke and flames trailing behind.

"We felt the intense heat as the plane went overhead.

"Seconds later it crashed in a sheet of flame."

Pieces of broken, twisted metal were spread over nearly a mile.

A small recreation park between the school and the railway line was covered with the charred, mangled remains of the aircraft.

Both tracks of the Brighton - Portsmouth line

Children in crash drama

It was only slightly injured.

Next door, Mrs. Gladys Guy, aged 51, was flung to the floor by the force of the explosion.

"When she got up she found a huge piece of metal had landed within inches of her head in the kitchen sink, but she did not get a scratch," said her husband.

Can you dress to win

Your Best **BARGAINS**

[advertisements]

65 *(cutting)* Daily Sketch *splash on the Vulcan bomber crash, May 1956.*

Squadron Leader Duncan Dobbie, a member of the Air Ministry's inquiry team, said they had carried out a thorough investigation, 'but we are really no wiser as to the cause of the accident, which is quite an exceptional one for this type of aircraft.'

The following year two jets crashed in Sussex. On 20 January 1956 a Meteor fighter came down on Wadhurst, killing the pilot and navigator and two villagers, and badly damaging several buildings. The jet had circled the village at a thousand feet just after three o'clock in the afternoon before suddenly turning on its side and plunging, with a terrible roaring sound, into the High Street. What added to the unreality of the situation was the discovery that the pilot, Flying Officer Leonard Stoate, was a Wadhurst man,

whose parents owned the store and sub-post office at Durgates, less than a mile from where the plane came down.

On 12 May a Valiant jet bomber narrowly missed two schools as it crashed on the railway line at Southwick, tearing up the tracks. Three of the four-man crew were killed, the fourth safely baling out, six people on the ground were slightly injured and six houses were damaged. Further possible injuries were averted by 77-year-old Arthur Stiller, who ran along the line to stop an oncoming train. St John Ambulance man George Shuttleworth found the co-pilot in his ejector seat, and was told that the aircraft had 'got into a lock', which meant that the pilot was unable to control its direction. This is perhaps technically a West Sussex story, as the Valiant hit the ground a few hundred yards across the county boundary, but the wreckage was scattered over almost a mile. Mick Bird, a pupil at Manor Hall Road School at the time, remembers that everything went dark.

> There were flames and clouds of smoke. You have to remember that we were still very much aware of the atom bomb, and for us children it was terrifying. Once the shock was over, though, we began to collect souvenirs – there were cartridges still warm to the touch. However, we were mustered in the school hall and told that it was a crime to keep any bits and pieces, so we had to hand everything over.

66 *One of the famous Red Arrows about to crash into the sea at Brighton.*

67 *Percival Terrace, Kemp Town, Brighton, after the collapse of a block of flats.*

There were red faces for the celebrated Red Arrows RAF display team at Brighton on 17 May 1980, when Squadron Leader Stephen Johnson's Hawk clipped the mast of a yacht and plunged into the sea. The pilot escaped, but the crash led to a change in the permitted minimum flying height above sea level from 35 feet to 100 feet. BBC Radio Brighton was broadcasting a commentary at the time, and a tyro broadcaster lost her chance of glory by panicking as the plane headed for the sea, blurting out the news and saying, 'Now back to the studio'!

The *Argus* headline was '94 Flee Cave-in' after a block of flats collapsed without warning in Marine Parade, Kemp Town on 13 November 1987. It was about three in the morning when walls crumbled in seconds as a vast hole opened up directly beneath the terrace. Tons of rubble smashed into cars, and water and gas pipes were fractured. 'More than 50 of those who narrowly escaped death were Brighton Polytechnic students who live in four of the Regency terraced buildings,' the paper reported. 'Others, including

68 *Bad driving conditions, Kemp Town.*

pensioners, were ordered to leave nearby terraces because of the threat of gas exploding. As shocked survivors watched in horror, cars and vans slipped into the gaping hole. Water and gas from fractured pipes mixed in a potentially lethal cocktail as emergency teams battled to cut off supplies.'

The hole eventually grew to 40ft wide and 12ft deep, and the entire seafront road was cordoned off.

> Hour by hour, a white Transit van slowly but surely slipped into the morass. A red C-registered Escort, its roof smashed in by the falling brickwork, was heaved onto one side as it gradually overbalanced into the hole. A small blue Fiat parked directly outside the terrace suffered the same fate.

It's something of a pleasure to end this story – and this chapter of mishaps – with a nod of appreciation to a group of commonly vilified men and women: 'The Brighton Police tow squad, normally engaged in towing away illegally parked cars at £67 a time, turned out free of charge to remove other cars in the danger line.'

Five

ROYAL AND OTHER VISITORS

Most of us like a good show, and don't need to look far for an excuse for one. Whatever our views about kings, queens and what some might call hangers-on, it's good to watch a parade and see the flags flying and the bunting flapping. This brief chapter records a few of the many visits to East Sussex by the great and the good – royalty, principally, but other public figures, too.

The tour of East Sussex by Elizabeth I in 1573 may be regarded as setting the tone for later royal occasions, although her progress was necessarily more slow than that of her successors – a steady 12 miles a day, in fact. Lord Burleigh told the Earl of Shrewsbury that 'The queen had a hard beginning of her progress in Kent and in some parts of Sussex where surely were more dangerous rocks and valleys and much worse ground than was in the Peak.' She stayed at Mayfield Palace, the home of Sir Thomas Gresham, founder of the Royal Exchange, in Lord Bergavenny's house at Eridge, and eventually reached Rye by way of Northiam. Famously, at Northiam on 11 August she sat down for lunch under a large oak tree near the church and left her dainty pair of damask shoes behind. (The tree still stands, although in a sorry state, while the slippers are housed in a glass case at Brickwall, now a school.) The following day she was met by the mayor and other dignitaries with such a show of pomp that she dubbed the town Rye Royal.

The House of Hanover were assiduous visitors to Sussex, helping to popularise several of the fledgling resort towns. William Henry, Duke of Gloucester – brother of George III – came to Brighton on 11 July 1765, enjoying balls and dinners, and breakfasting with Sir Thomas Pelham at Stanmer. The Duke of Cumberland, another brother, was greeted by the ringing of church bells, illuminations and salutes from the guns of the forts and ships lying at anchor when he first came in 1771, and the 72-year-old Princess Amelia received a similar reception in 1782. Unfortunately, one of the guns giving the royal salute misfired, and the head gunner's hand was so badly injured that it had to be amputated.

69 *A less than flattering early 19th-century cartoon of the Prince of Wales on his way to Brighton, with a team of donkeys presumably easily recognisable at the time.*

George, the Prince Regent, takes precedence in this account because of his special influence in boosting Brighton's reputation. He first visited the town on 7 September 1783, and stayed for 11 days. A salute was of course fired at the local battery (killing the gunner – health and safety regulations evidently left a good deal to be desired in those days) and a firework display spangled the evening sky. Next day 'Prinnie' rode out with stag hounds and attended an evening ball at the *Castle Inn*, setting the tone for his future visits.

There was already some criticism of his lifestyle when he made a ten-week visit the following year, taking the sea-water cure and (so his detractors said) mixing with some disreputable people. He was, after all, a drinker, a gambler and a spendthrift as well as being intelligent, artistic and witty. He married Maria Fitzherbert, and almost certainly had children by her, before deserting her, denying the contract and entering a disastrously discordant marriage with Princess Caroline of Brunswick. He built the Royal Pavilion and, whatever view is held of his morals, was a 'good thing' for Brighton.

Queen Victoria, though irreproachable on the moral front, was not a success in Brighton. She and the locals seem to have regarded themselves with mutual disdain. She first visited the town as Queen on 4 October 1837, being greeted with a floral arch at Preston Circus and a vast floral amphitheatre at the north gate of the Royal Pavilion. She was to come several more times, but she complained that 'the people are very indiscreet

70 *Edward VII, a great racegoer, at the renowned Lewes course. It was closed in September 1964, against the wishes of the management, and sold privately in 1971.*

and troublesome here really, which makes the place much like a prison'. After her last visit in 1845 she used Osborne House, on the Isle of Wight, as her country retreat, and the Pavilion was sold to the town five years later.

Edward VII was much more like Prinnie in temperament, and brought the same kind of razzmatazz with him, both as Prince of Wales and when he became King. Indeed, his visits to Brighton helped restore some of its lost fashionability, and in 1908 the Corporation renamed the Kemp Town ward King's Cliff in his honour. He was often in Sussex for the racing and shooting, but he occasionally performed official duties too.

In 1882, for instance, he and his wife Alexandra visited first Hastings to open Alexandra Park and then neighbouring St Leonards to open a convalescent home for poor children. The following year the couple were in Eastbourne, opening a new hospital and a number of other facilities. The hospital was a memorial to his sister, Princess Alice, who had taken an interest in the care of the sick after seeing the misery of wounded soldiers

71 *Visit of the Lord Mayor of London to Hastings, 28 November 1908. 'We had a grand day here last Saturday,' wrote the sender of this postcard. 'We all had flags from the top window. It was fine fun. This road was decorated better than any.'*

72 *Duchess of Albany's visit to Hastings, 1913.*

73 On 1 April 1928 Brighton expanded to five times its original size, taking in Ovingdean, Rottingdean, most of Falmer and parts of Patcham and West Blatchington. Guests of honour at the Greater Brighton celebrations were the Duke and Duchess of York, later George VI and Queen Elizabeth.

74 Aviator Amy Johnson lands at Frowd's Field, Hampden Park, Eastbourne on 26 August 1930. Four months earlier she had become the first woman to fly solo from Britain to Australia.

in the Austro-Prussian war. She had formed a brief but special relationship with Eastbourne, moving to the town in 1878 but dying there from diphtheria months later at the age of just 35. Before the war memorial was erected Princess Alice's tree stood at the junction of South Street and Cornfield Road and can be seen on many early postcards: she had planted it herself.

George V is most strongly associated with Bognor in West Sussex, giving it the Regis suffix, but he and Queen Mary had a lengthy holiday at Compton Place, Eastbourne (home of the Duke of Devonshire) in 1935, before the silver jubilee celebrations. They took regular walks along the beach between the Wish Tower and Holywell, and a beach hut on the front now bears the royal initials. In her diary of 27 February the Queen wrote of 'an awful night of wind and rain'. This eventually cleared up 'and we drove along the esplanade and then to Beachy Head, a nice drive. Walked in the grounds here and actually picked primroses.'

The Windsors, of course, have had their star performers, and many readers will have memories of seeing various members of the royal family in East Sussex over the years. The Queen Mother, who as Duchess of York had a short holiday in Eastbourne with the Duke in 1935, was often here during her long life. She was Lord Warden of the Cinque Ports and Patron of Chailey Heritage School, two roles she took seriously.

Our present Queen and her children have regularly been seen in East Sussex, but the greatest impact among the younger generation of royals was undoubtedly made by the late Princess of Wales, 'Lady Di'. She first appeared in Sussex in an official capacity in 1985 as Patron of British

75 *Sir Winston Churchill was a prize guest after his triumph as a war leader. Here he is seen on his way to the Dome in Brighton, having received the freedom of the borough. The Mayor of Brighton, Alderman T.E. Morris, is seen on his right.*

76 *Churchill visits the Winkle Club at Hastings in September 1955 – five months after resigning as Prime Minister at the age of 80. The Winkle Club is a male-only charitable organisation established in 1900 to raise funds to help poor children, work it continues to do. Members have to pay a fine if they are unable to produce a winkle when challenged with the cry 'Winkle up!' The Queen Mother was made an honorary member, and the club was represented at her 100th birthday celebrations in London.*

77 *Another picture of the Winkle Club visit, at which Churchill was installed as a member. The fishing boat* Enterprise *is in the foreground, with the East Hill behind and the famous black 'net shops' (used by fishermen to store their equipment) on the right of the picture. The* Enterprise *was given to the Old Hastings Preservation Society by Harold Pepper in 1955, and the following year she was moved into the Fishermen's Museum on the Stade, where she now takes pride of place.*

78 *The Queen Mother at the 80th birthday celebrations of Chailey Heritage School, 1983. As patron of the Heritage, the leading school for children with serious physical disabilities, she paid six visits over the years, this being her last.*

Red Cross Youth, spending almost three hours at Hindleap Warren, near Chelwood Gate, the London Federation of Boys' Clubs activity centre.

Diana had a charisma more commonly associated with film stars. As the habit of deference fades it may, indeed, come to pass that a growing number of organisations will prefer to have their great occasions marked by the presence of TV personalities and pop stars rather than minor royalty, but it seems safe to predict that there will be some events for which the Buckingham Palace imprimatur is still the ultimate seal of approval.

79 *The visit of Princess Elizabeth to Hastings in 1951, with hundreds of local schoolchildren curtseying as she passes. She became Queen the following year.*

Six

WAR

The county of Sussex was forged in war – the kingdom of the South Saxons, occupying land wrested from the Romanised Celtic inhabitants of the area during the late fifth century – and it has spent precious little time untouched by it ever since. The Saxons themselves were regularly mauled by the Vikings (and for a time lived under the rule of the Danish King Canute) until, on 14 October 1066, they were overthrown by William of Normandy at Senlac Hill.

Exactly where the Normans landed is unknown, but it was clearly in East Sussex, and probably close to the place now known as Norman's Bay. The great battle got its name from the nearest settlement of any size at the time, but it took place on an empty hillside miles from Hastings where the conquerors would later build Battle Abbey in celebration. The altar of the abbey church was sited at the very place where King Harold fell and, despite the later destruction of the building, it can still be visited today.

The story needs no re-telling here, but a few words certainly need to be said about the next East Sussex date with national implications. On 14 May 1264 the powerful magnate Simon de Montfort trapped Henry III's forces inside Lewes, with the River Ouse and its marshes behind them. After Henry's son, the Black Prince (later Edward I), had spurred his cavalry against de Montfort's left flank, pursuing the Londoners who composed it miles from the battlefield, the town was free for the rebels to attack. A Lewes monk reported that Henry's army was utterly overthrown by midday: 'the king was much beaten with swords and maces, and two horses killed under him, so that he escaped with difficulty.'

With the royalist death toll estimated at 2,700, the King was captured at Lewes Priory. The significance of the event is that Henry

80 *Bayeux Tapestry.*

62

the wynde mylles

the valey comyng from powge But not soo Brithampton and the vilage hove.

Hoove Churche

The towne of brithampton

the valey comyng from Lewestonou

a felde in the middle of the towng

Hove vilage

the towne cage?

Vpon this whyte may stond C. lyghtyng pontefied by any vision there.

here landed the Galeys?

Shippes may ride all somer in 30 ampole the townes in fathome water.

Thesse grete shippes rydeng hard alôd the shore by shoteng into the felde quelis & shipfies opprosse the towne that the countrey dare not aduenture to resfue it

was obliged to sign a treaty known as the Mise of Lewes, giving new chartered boroughs representation in Parliament. Fifty years on from *Magna Carta*, this was a significant advance in the gradual, drip-drip progress towards a democratic form of government.

A coastal county is always vulnerable to attack from sea, and during the medieval period there were regular attacks from the French – very often, it

81 *A contemporary drawing showing a French fleet off Brighton in 1545. Brighton is small and undefended, while Hove consists of little more than two streets.*

must be said, repaid in kind. There was a particularly bloody attack on Rye by a 3,000-strong force on 15 March 1360, virtually destroying Rye and Winchelsea. A chronicler wrote of the assault: 'Before sunne rising (the French) entred the towne, and finding the inhabitants unprovided to make anie great resistance, fell to and sacked the houses, slue manie men, women and also children, and after set fier on the towne.' Six years later the number of houses in Winchelsea listed as 'waste, burned and uninhabited' stood at 385. The so-called Hundred Years' War between England and France lasted from 1337 until 1453, and at the end of it, in 1448, there is another record of utter devastation for Rye and Winchelsea. No buildings earlier than that period survive, unless made of stone.

During the following century Henry VIII's political relationships ensured a busy time for those living by the coast, one of the issues being England's retention of Calais. In 1545 there was a massive attack on Brighton by French ships, and it seems that the town was burnt to the ground. A drawing of the time shows the town with a fishing fleet drawn up on the beach and with no defences. Brighton, not surprisingly, was fortified in 1559.

This attack was part of the campaign which, a week previously, had sunk the pride of the Tudor navy, the *Mary Rose*, in the Solent. After firing Brighton, a party of invaders moved on to the East Blatchington area of Seaford. Here they were put to flight by troops commanded by Sir Nicholas Pelham. This achievement is remembered on his monument in St Michael's church, Lewes, the punning inscription telling us:

> What time ye French sought to have sackt Seafoord
> This Pelham did Repell them back aboord.

With Elizabeth on the throne, the Spanish became the chief enemy, and in 1588 the great Armada sailed towards England. It was first seen off Selsey in West Sussex on Friday 19 July and one can imagine the fascinated horror of spectators along the cliffs as it struggled slowly eastwards, always harried by the English fleet. Beacons were lit on the highest hilltops, such as Ditchling and Crowborough, and rows of stakes were planted across fields and commons to delay an enemy advance. A mound at Pevensey Castle is thought to have been thrown up as a gun base, and rough and ready defences were doubtless erected in desperation: the nation was horribly unprepared. On 27 July the flotilla lay becalmed off Fairlight, its last dalliance with Sussex. It soon sailed away to defeat, and the celebrations began. At Lewes a barrel of gunpowder was consumed 'in shooting off the great pieces in the castle'. In a personal, rather than public, gesture of relief a Warbleton couple took their baby boy to be christened, naming him Bethankfull.

During the late 17th century the French were again the enemy. An Anglo-Dutch fleet lay off Beachy Head under the command of Lord Torrington on 30 June 1690, and the very future of the Protestant monarchy in England was at stake. Two years previously William and Mary had been invited to the throne in the so-called Glorious Revolution, but William was now in Ireland, preparing to do battle with a French army under the deposed James II; Torrington's fleet was charged with keeping at bay a French fleet considerably larger than his own.

The Battle of Beachy Head began just after nine o'clock in the morning, and it went very badly. The 70-gun warship *Anne* was one of the ships to suffer. Her masts were shattered and she had been repeatedly hit by enemy shot. More than a hundred of the 460-strong crew were dead, and when Torrington ordered his crippled fleet to retreat she had to be towed. 'Our main mast, mizzen mast and boltspit shattered all to pieces,' reported her captain, John Tyrrell the next morning,

> and foremast shot quite away. We received above sixty shot betwixt wind and water. Our ship being so much battered, God Almighty send us clear of our enemies. My men were very skillful and behaved themselves with a great deal of gallantry.

82 *Armada cresset.*

On 3 July the *Anne* was run ashore in strong winds between Fairlight and Camber Castle. 'I lie within pistol shot, at high water, of the shore,' Tyrrell told the Admiralty that evening, 'and at low water one may walk around the ship. If the French fireships do not come in and burn me I hope to save her, though the water comes into her as the tide ebbs and flows'. By the next day he had to make a tough decision. The French were bombarding Hastings and Rye, so Tyrrell decided to burn his ship to prevent her being taken as a prize. The blackened timbers of the *Anne* still lie off Pett Level and can be seen at very low tides.

Although Lord Torrington was imprisoned in the Tower of London for his abject retreat, the story has a happy ending. William won the decisive Battle of the Boyne in Ireland on 1 July, and on 5 July (and for no apparent reason) the French turned tail off Beachy Head when total victory seemed within their grasp. The monarchy, and the democratic system it stood for, had survived.

With war against Napoleon in the offing at the end of the 18th century, the Sussex coastal region was turned into something of a military camp, with

83 *Crimean prisoners of war in Lewes.*

substantial barracks at Bexhill and 15,000 troops based at Brighton alone – and the soldiers, particularly the hastily recruited county militias, were not on their best behaviour. There had been a poor harvest and a severe winter leading to food riots. The militias, many of them pressed men unable to find the cash to buy themselves out, were sympathetic to the grievances of the general population. On Friday 17 April 1795 some 500 members of the Oxford Militia mutinied and marched with fixed bayonets from their barracks at Blatchington, near Seaford. Some of their number had recently been jailed for raiding bakers' shops in Chichester but had been freed by a violent mob. Now they marched to Seaford, seizing quantities of flour, bread and meat and selling them at cut prices to local people. Next they went to the tide mill near Bishopstone and forced the crew of a sloop loading flour to sail their cargo to Newhaven. Finally they marched to Newhaven itself, taking possession of the town and selling the commandeered flour at what they claimed to be a fair price.

Not surprisingly, the authorities reacted strongly. Two of the ringleaders, privates James Sykes and William Sampson, were hanged at Horsham, while two other privates, Edward Cooke and Henry Parish, were shot by firing

squad at Goldstone Bottom in Brighton, later the site of Brighton and Hove Albion's stadium. The rebellion was over.

The Napoleonic Wars have left a wide range of defences in East Sussex, including the chain of martello towers, Newhaven Fort, the Redoubt fortress at Eastbourne and the Royal Military Canal, running from Cliff End, near Pett, to Shorncliffe in Kent. The Crimean War, which followed a generation or so later, has left few artefacts, but the housing of Russian, Swedish and Finnish prisoners of war in the town has become a part of Lewes folklore. At the outbreak of war in 1854 it was decided that the House of Correction would make a suitable gaol but that soldiers would need to be stationed locally in order to protect the local population.

'The first 150 prisoners arrived on 5 October, and are said to like their food amazingly. They have taken up manufacturing puzzles and other toys in wood, which they dispose of to visitors (freely admitted) and to shops in

84 *It's Sunday 24 May 1900, and these cadets, posing outside the old County Hall (now the Crown Court) in Lewes are celebrating the Relief of Mafeking in the Boer War four days earlier. The gun is the replica of a Boer 'Long Tom'.*

85 *Injured Indian troops being treated at the Pavilion. Since the days of the sea water cure, the resort had been known as Dr Brighton, and the new arrivals were now called 'Dr Brighton's Indian patients'.*

the town and in Brighton. Each cell (three to a cell) has a copy of the Scriptures, and they are about to get a Russian-speaking chaplain.' Some of these puzzles can be seen in Anne of Cleves Museum. By 1856 the war was over, and the 326 prisoners and their captors parted in good spirits, accompanied by the Lewes Saxon Horn Band and crowds of local wellwishers. A memorial paid for by Tsar Alexander II stands in the churchyard of St John sub Castro, remembering the 28 prisoners who died while at Lewes, chiefly from pneumonia.

The colourful incomers to East Sussex during the First World War were from another part of the world altogether. From as early as December 1914 and until early 1916 thousands of Indian soldiers wounded in the trenches in France were cared for in Brighton. One of the three hospitals created for them was in the former workhouse (renamed the Kitchener Hospital), another was in the York Place schools, while the third – and most appropriate, given the style of architecture – was at the Royal Pavilion and Dome.

Major P.S. Lelean from the War Office was charged with organising the arrangements, and he acted with admirable speed. Faced with the fact that

the Pavilion was 'a crowded museum' and the Dome had 1,500 seats clamped to its tiers, he immediately enlisted the help of local youngsters in removing these obstacles: the *Brighton & Hove Gazette* reported that 40 'sturdy energetic young fellows' from the Boys Brigade were used. Khaki-coloured linoleum was brought from London to cover the entire floor area, and was laid the very same night. The following day, a Sunday, a detachment of troops from the Sussex Yeomanry dealt with a consignment of beds. By the Wednesday he was sending photographs to his masters 'showing the Dome as a completed Hospital with radial beds around a centre embedded in tropical foliage.' These were delivered to Lord Kitchener, who immediately took them to the King.

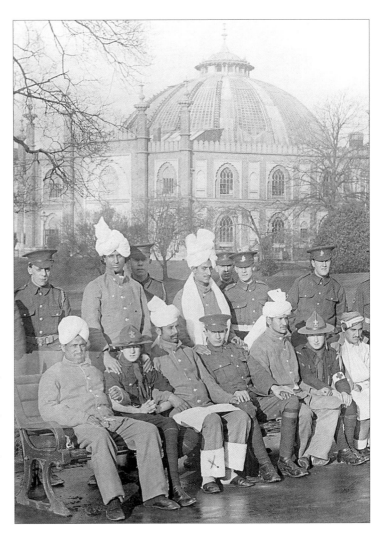

86 *Indian soldiers and some young visitors in the Pavilion Gardens, with the Dome as a backdrop.*

Such was the carnage of war that by November 1914 there were already 1,800 Indian casualties. The first of them arrived at the Pavilion on Saturday 5 December and were installed in the Music Room and the North Drawing Room. The first large contingent of 345 followed on 14 December, two hundred being taken to the Pavilion. Most were suffering from gunshot wounds.

Although patients at the Kitchener Hospital were not allowed to leave the grounds (it was, by all accounts, not a happy ship), the men at the Pavilion socialised with the locals and were taken on car rides and visits to the theatre. George V himself made several visits to Brighton, on 15 August 1915 (accompanied by the Queen and Lord Kitchener) presenting the VC to Subadar Mir Dast, who despite being wounded had managed to bring eight British and Indian officers to safety. The *Times of India* printed his memories of Brighton:

> I received the kindest of treatment. People of rank and the greatest soldiers and statesmen came and they talked so nicely to me. They expressed their admiration for

87 *Unveiling of the Chattri by the Prince of Wales on 1 February 1921.*

the work done by the Indian soldiers in the field. Lastly, my happiness was crowned by the visit of his Majesty the King-Emperor. My heart was filled with joy and gratitude when his Gracious Majesty with his own hands pinned the Victoria Cross on me, shook hands with me and congratulated me on winning the distinguished order. The King spoke in English and his speech was translated to me by a British officer in Hindustani. The purport of it was that he was highly pleased with the valour of the Indian Army, and it gave him the greatest pleasure to decorate brave Indian soldiers. Another visit gave me equal pleasure. It was from the Queen Mother, Queen Alexandra, who condescended to come and see me.

Most of the Indian patients recovered from their wounds, some of them returning to the front. Muslims who died were buried in the grounds of the mosque in Woking, Surrey, while Hindus and Sikhs were cremated at a site 500 feet above sea level on the Downs near Patcham. Here, a few years later, the monument known as the Chattri was raised in their memory.

Volunteers had been in great demand at the outbreak of war ('Your Country Needs You!'), and more than 4,000 Sussex men had enrolled by early 1915 under the leadership of Colonel Claude Lowther. He was the MP for Eskdale in Cumberland, but he had a family home at Herstmonceux Castle, and he formed three battalions of men which became the Southdown battalions (the 11th, 12th and 13th) of the Royal Sussex Regiment. Popularly known as 'Lowther's Lambs', they had a Southdown sheep as their mascot. A.W. Busbridge wrote a marching song for them:

For the Sussex stock is staunch, and the Sussex blood is true,
And the Sussex lads are keen when there's soldiers work to do.
Hear us tramp, tramp, tramp till the country is a camp
And we start the little business we have sworn to carry through.

88 *Commandeering horses for the front outside the* Bell Hotel, *Ticehurst, during the First World War.*

The colonel's father provided land at Cooden, near Bexhill, for training manoeuvres, but wet weather caused chaos, and the men were later billeted in various premises in the community. Since they were dressed in distinctive navy blue uniforms, the locals knew them as 'Kitchener's Blues', declining to change the nickname after the issue of khaki uniforms in the spring of

89 *First World War military camp at Malling, Lewes.*

90 *The grammar school in Dyke Road, Brighton (now BHASVIC) became the 2nd Eastern General Hospital during the First World War, the pupils temporarily returning to their former premises in Buckingham Road. Its first patients were men of the 2nd Royal Sussex Regiment, wounded during the retreat from Mons. The photograph shows a funeral carriage leaving the hospital.*

1915. The troops eventually left for France in March the following year, and their first casualty was Private David Dunk from Bexhill. They met with terrible losses at Ferme du Bois, at the Somme, Ypres, Passchendaele and other battlefields, and by the end of the war more than a thousand were dead or missing.

A series of airship stations had been created along the coastline, and the Royal Naval Air Station at Polegate was among the most important of them. The task of the Zero airships was to keep the Channel safe from German U-boats, harassing and destroying any they found. They were frail-looking craft, their balloons filled with hydrogen, with a gondola beneath for the three crew: the wireless telegrapher/observer in front, the pilot in the centre cockpit and the mechanic at the rear. Each airship carried a 60-gallon can of petrol and had two 65lb bombs strapped to the side of the gondola.

On 22 December 1917 a sudden change in the weather brought disaster. All five airships took off that morning in good visibility and light winds. They patrolled for several hours, finding nothing, and then cloud began to drift in from the north-east. During the next two hours the cloud intensified, eventually bringing snow, and the winds increased. By three in the afternoon, with visibility dwindling, the decision was taken to return to base.

Since a mass landing was deemed dangerous in the ever-worsening conditions, the ground controllers ordered the pilots to scatter independently and find safe landing sites where they could. Two (Z7 and Z19) landed near the coastguard hut on Beachy Head, while a third (Z6) moored near Uckfield, the crew being invited into a grand country house where dinner was served by the butler. The other two, Z9 and Z10, landed in a field at Halfway Farm, between Jevington and Willingdon: the farmer and his 12-year-old son brought out hot drinks and food, and a ground crew later arrived from Polegate to help them moor the Zeros in the strong wind.

With the wind still increasing there were fears for the safety of the two airships moored at Beachy Head, so the crews were ordered to take advantage of improved visibility and return to base. This was a fateful decision, for although Z19 landed at Polegate successfully, Z7 (piloted by the experienced Sub Lieutenant Swallow) was finding the conditions hazardous. Victor Dodd,

91 *One of the U-boats hunted by the Polegate airships. After the war this one was beached and broken up at Hastings. The sign reads 'Dangerous to sit on the gun'.*

92 *A post-war beach scene at Hastings, with the U-boat seemingly taken for granted.*

his observer, was leaning out of the forward cockpit with an Aldis lamp, attempting to pick out a route in the snow-choked darkness as they flew low over farm buildings and huddled sheep, when he let out the cry: 'Something dead-ahead!'

Too late, in the murk, he had spotted the balloon of Z10 in the field at Halfway Farm. The bottom of Z7's gondola tore the top of the other airship's balloon, and her exhaust ignited the escaping hydrogen. Swallow was engulfed in flames, while his two companions leapt for their lives, both sustaining serious injuries. In the field below, meanwhile, the crew of Z9 raced to the burning Z10, pulling the men to safety, but Lieutenant Victor Watson (in charge of the ground party), mistakenly thought that one of the crew was still aboard, returned to the airship just as one of its bombs exploded and was caught in the blast: one of his arms was blown off. In an act of amazing heroism two other members of the ground party – air mechanic

93 *Temporary war shrine at Hastings. One of the texts reads: 'Here by the margin of the restless sea we raise this to their hallow'd memory.'*

Harold Robinson and boy mechanic Eric Steere – dashed to the burning wreck of Z7, found Sub Lieutenant Swallow dead in the cockpit and, blistering their hands in the fierce heat, carried the bombs away from the airship to prevent a further explosion. They and Victor Watson were awarded the Albert Medal for 'distinguished acts of bravery'.

After the end of this dreadful war there were reminders of it in the tanks and other weapons put on display in public places, and in the awesome sight of huge U-boats washed ashore on the beaches at Hastings, Bexhill and at Beachy Head. War memorials sprouted in every town and village, since no community had escaped loss in this 'war to end all wars'.

94 *The permanent war memorial unveiled in Alexandra Park, Hastings, in March 1922.*

The next world war was, of course, to follow hard on its heels, and this time the full force of enemy weapons was felt by the people of East Sussex themselves. With an invasion a real threat, the beaches were transformed – mined, covered with barbed wire, and their approaches littered with large concrete blocks to stop tanks in their tracks. The piers at Brighton, Eastbourne and Hastings had parts of their decking removed to prevent a landing. Shanty towns along the beaches were removed, and the little community at Tide Mills, east of Newhaven, including the marine annexe of Chailey Heritage on the foreshore, was evacuated, the buildings being used for target practice.

95 *A statue of King George IV being removed from the northern enclosure of the Steine to make way for Brighton's war memorial, unveiled by Earl Beatty on 7 October 1922. It records the names of 2,597 men and three women of Brighton who fell in the First World War. The statue was taken to the North Gate of the Pavilion, where it stands today.*

97 *German U-boat UB 121 stranded near Beachy Head.*

96 *Hastings Peace Day procession, 1919.*

The war can be said to have begun for Eastbourne on the night of 20 March 1940, when the merchant ship SS *Barnhill* was bombed off Beachy Head. The Eastbourne lifeboat *Jane Holland* and a tug from Newhaven went to her rescue, and the badly injured captain was rescued only after crawling along the burning deck to pull a bell rope with his teeth.

It was close to the wreck that the first bombs were dropped in the Eastbourne area, on 3 July. It was a harmless attack, and far from typical of what was to follow, for, surprising as it seems, Eastbourne was eventually to be designated by the Home Office as 'the most raided town in the south-east region'. There

were, of course, cases of retreating German bombers shedding their loads over the town as they made good their escape, but the extent of the attacks on Eastbourne was much more severe. In all, 200 people were killed or died of their wounds, and more than 500 were seriously injured. More than 475 houses were destroyed, with about a thousand seriously damaged and all of 10,000 slightly damaged. The Bourne Street/Langney Road area was so frequently targeted that it became known as 'Hell Fire Corner'.

Brighton experienced its first air raid on 15 July 1940, when Kemp Town was bombed. Altogether 198 people were killed and 357 seriously injured,

98 *Brighton seafront in the early months of the war, with the West Pier breached against invasion.*

100 *RSPCA inspector Teddy Winn helps treat a dog buried in the rubble after a bombing raid in the Churchdale Road area of Eastbourne on 28 March 1941. Three people were killed, including a six-year-old boy.*

99 *Brighton Town Hall sandbagged at the outbreak of war.*

101 Cavendish Hotel, *Eastbourne, 4 May 1942. Nine Messerschmitt Me109 fighter-bombers strafed the town with cannon and machine-gun fire before dropping high-explosive bombs. Five people were killed and 36 injured. Several RAF personnel billeted at the* Cavendish Hotel *were trapped in the east wing after the blast.*

with more than 200 houses des-
troyed, 894 seriously damaged and
more than 14,000 slightly damaged.
One of the worst incidents was the
raid of 14 September 1940, when a
bomb scored a direct hit on the
Odeon cinema in St George's Road,
Kemp Town during an afternoon
performance when there were about
300 people in the house. Only four
people were declared dead at the
scene (including six-year-old Pamela
Sturgess and 15-year-old Frank
Stutterford, who was on duty for the
St John Ambulance), but the final
death toll was 14, including eight
children, and many people were
badly injured.

The young June Longly was in the
cinema with her mother and
brother:

102 *Trafalgar Street,*
Brighton, after a bomb
attack on 25 August
1940.

The film was a comedy called *The
Ghost Comes Home*, and we had
only seen a few minutes of it when
there was an enormous bang
accompanied by an awful lot of noise
– difficult to describe, but it was really
awful. There were clouds of dust and
dirt, hanging as if it was a curtain. All
this happened so quick that you
couldn't put a time to it. This is a memory that has stayed with me since that day; I
can still see it now. I was then aware that a large part of the roof was missing. In fact
the sky was clearly visible. The screen was split from top to bottom, and the dust and
dirt seemed to be coming from where the torn screen was. I remember that my mouth
was full of grit and dust as by this time the whole of the cinema was full of this dirty
stuff floating through the air.

I remember seeing someone trapped under a large piece of the roof, calling for
help, trying in vain to get out from underneath it. I was then picked up by a man and
carried towards an exit, which was at the front of the cinema. It turned out that this
man was related to the lady who owned and lived in the block of flats next to ours.
I later learned that his name was de Haviland, and that he was a member of the
famous aircraft company. We left the auditorium and went down some steps into the
corridor leading to the foyer. There was a man lying on the floor. I was told not to
look, but it was too late – I had seen him. He looked to be dead.

103 *Wilson's Laundry bombing, Brighton, February 1944.*

Although, surprisingly for a port town, Newhaven escaped relatively lightly, with only 15 deaths from enemy action (11 of them killed when a single bomb fell on three houses in Folly Field on the night of 11 December 1940), neighbouring Seaford suffered more than any Sussex town other than Eastbourne and Brighton. In all, 23 people were killed and 16 were badly injured.

And the county town? There had been so many false alarms – an estimated 400 in the previous two years – that few people showed much concern when the sirens sounded at lunchtime on 20 January 1943. This, however, was to be the 'Lewes blitz'. Six 250kg bombs were dropped across the town, all of them exploding on impact. One of them bounced off the wall of the old

Naval Prison, where the Crimean prisoners had been housed, and blew a crater in the roadway at the corner of East and North Streets. Another caused serious damage to houses at the present site of the West Street car park. In the 30 seconds of the raid two people were killed and 11 seriously injured.

104 *Pelham Road, Seaford, after a raid on 5 November 1941. Five people were killed. The site is now occupied by Welbeck Court.*

Newhaven was the embarkation point on 19 August 1942 for the disastrous Dieppe Raid, in which a force of almost 5,000 Canadian soldiers were trapped on the beaches and more than 900 of them slaughtered. By 1944 the tide of battle had turned, and troops were setting off from Newhaven with success ahead of them. Another war was about to end – although nobody any longer entertained the belief that it would be the last.

105 *Soldiers at Newhaven about to leave for France soon after D Day, June 1944.*

Seven

CRIME

There was once a palace of the Archbishops of Canterbury at South Malling, across the River Ouse from Lewes, and here on the night of 29 December 1170 came the four knights who had just killed Thomas à Becket. 'On entering the house,' wrote Dean Stanley,

> they threw off their arms and trappings on the large dining-table which stood in the hall, and after supper gathered round the glazing hearth; suddenly the table started back, and threw its burden on the ground. The attendants, roused by the crash, rushed in with lights and replaced the arms. But soon a second crash was heard, and the various articles were thrown still farther. One of the conscience-stricken knights suggested it was indignantly refusing to bear the sacrilegious burden of their arms.

One should perhaps take this moral tale with a pinch of salt, but there are plenty of tales of murder and blood-letting in East Sussex over the centuries for which the evidence is all too detailed.

106 *A print showing the burning of Protestant martyrs at Lewes. During the reign of Queen Mary (1553-8) no fewer than 17 were put to death in the county town. Four were burned in Mayfield, and there were victims in other parts of Sussex too. A memorial to the Sussex martyrs was raised on Cliffe Hill, above Lewes, in 1901.*

On a dark and windy night in March 1742 Allen Grebell set off home from Lamb House in Rye having accepted the loan of his brother-in-law's cloak. This turned out to be a fatal decision. Lurking in the shadows was a local butcher named Breeds who had a grudge against the brother-in-law, Thomas Lamb, and who jumped to the wrong conclusion when he recognised the cloak. Grebell was stabbed to death, and the perhaps intoxicated Breeds ran around the town crying that 'butchers should kill Lambs' – rather strong evidence against him. He was convicted of murder and executed, his body hung in a cage on the marshes outside the town, in accordance with the practice of the time. The murder is mentioned on Grebell's memorial slab set into the floor of the north chapel of the parish church:

> Here lyeth the body of Allen Grebell, Esq, who, after having served the office of Mayor of this town for ten years with the greatest honour and integrity, fell by the cruel stab of a sanguinary butcher, on March 17th 1742.

107 *A murderer's skull inhabits the original cage in which his body was hung out on the marshes near Rye in the 18th century.*

Several smugglers were shot while about their nefarious business, and it's plain that many people regarded their deaths as murder, even if they were caught red-handed. Thomas Noakes was shot at sea by a customs officer on 22 May 1783 at the age of 24, and his tombstone in St Clement's churchyard at Hastings is unrepentant:

> *May it be known, tho' I am clay*
> *A base man took my life away;*
> *But freely him I do forgive*
> *And hope in Heaven we shall live.*

Daniel Skayles was also caught in the act, but his gravestone at Patcham, north of Brighton, simply tells us that he was 'unfortunately shot' on the evening of 17 November 1796.

The case of the 29-year-old fisherman Joseph Swaine is less straightforward, since his boat was apparently never properly searched. What we do know is that he brought it ashore at the Stade at Hastings in March 1821 and that George England from the Blockade attempted to inspect it. Exactly what followed is uncertain because of conflicting evidence at the subsequent Old Bailey trial. Certainly there was an argument and Swaine, a family man with five young children, was shot dead. England was arrested, tried for wilful murder and condemned to death, winning a reprieve when he claimed that he had only been trying to do his duty.

On hearing of the reprieve the fishermen of Hastings went on strike. They also created a headstone for Swaine in the churchyard of All Saints church 'in commiseration of his cruel and untimely death and as a record of the public indignation at the needless and sanguinary violence of which he was the unoffending victim'.

One of the most notorious smugglers was Stanton Collins, an Alfriston butcher, and to take a tour of the *Market Cross Inn* (his former house) is to understand its attraction for him. The place is a warren of stairways and passages, the 21 rooms having no fewer than 47 doors – wonderful for confusing the authorities. He was clearly a man of some clout. When a conflict arose at what is now the United Reformed Church, the Collins gang was called upon to get rid of an interloping preacher. Although he was found guilty of only minor smuggling offences, he was eventually sentenced at the Lewes Winter Assizes of 1831 to seven years' transportation for stealing barley from a Litlington farm. He was resilient, however: he returned to England after serving his sentence and was employed as manservant, and later as footman, to the rector of Herstmonceux.

In days gone by killers would sometimes get away with crimes which today's laws, however liberal, would surely condemn. In June 1820 nine-year-old John Archdeacon was teasing a mule, and for this offence its owner, William Picknell, beat him to death. Picknell was charged at Lewes assizes with 'feloniously killing and slaying,' but he was acquitted. The grim story is told on the boy's gravestone outside the entrance of All Saints church in Hastings.

Here's lies an only darling boy
Who was his widow'd mother's joy ...

There was an echo of this leniency in Eastbourne 40 years later, after Thomas Hopley, who ran a school in the town, beat a frail 15-year-old pupil so severely with a walking stick and skipping rope that he died. True, Hopley was found guilty of manslaughter and sentenced to four years' penal servitude, but after this slap over the wrist he was allowed to return to teaching.

There was no escape of any kind, thankfully, for the perpetrator of Celia Holloway's murder – her husband, John. This was one of Brighton's most sensational cases of the 19th century, the sordid story beginning with a report in the *Herald*: 'The body of a woman, minus head, arms and legs, was found buried in a hole in the ground in a shaw, or copse, within ten yards of Lover's Walk, at Preston.' Five years earlier Holloway had married 27-year-old Celia Bashford, and they had been unhappy together from the

start. Holloway left her and moved into a house in Margaret Street with a woman named Ann Kennett, but Celia was pregnant and when she applied for parish relief he was arrested on a charge of neglecting to support his wife and ordered to pay her 2s. a week. Ann Kennett turned up with only half that amount, at which Celia struck her with a poker. Holloway allegedly went to Celia's lodgings and told her, 'I will make away with you before long'.

He was true to his word. He later confessed to suffocating her, dismembering her body and borrowing a laundress's barrow to wheel the trunk of Celia's body to Lover's Walk. There he buried it in a hole he dug beneath the trees, but it was accidentally found soon afterwards, while the legs, arms and head turned up in a privy in Margaret Street. Holloway and Kennett stood trial together, but she was acquitted. The judge, finding Holloway guilty, sentenced him to be hanged and his body to be 'dissected and anatomised'.

The *Herald* reported the execution at Horsham and its aftermath:

108 *A contemporary drawing of John Holloway (seated) at Horsham gaol.*

109 *Memorial plaque to Celia Holloway at St Peter's church, Preston Village.*

BENEATH THIS PATH ARE DEPOSITED
PORTIONS OF THE REMAINS OF
CELIA HOLLOWAY,
WHO WAS BRUTALLY MURDERED,
IN THE LOVERS WALK IN THIS PARISH,
IN THE YEAR OF CHRIST 1831,
AGED 32 YEARS.
"RESTING TILL THAT DAY WHEN THERE SHALL BE NO MORE SIN."

> After the body had hung about a quarter of an hour, a man ascended the scaffold
> with the executioner and, seating himself on its edge, took off his hat. The hangman
> then loosened Holloway's hands, the palms of which he rubbed on the forehead of
> the person who, we observed, was afflicted with a wen, which he superstitiously
> supposed would be cured by the process, for which he paid 2s 6d.

After the under-sheriff told the executioner that he would not suffer a repetition of such proceedings until after the body was cut down, the halter 'was disposed of, as a relic, to a young man at Lewes, for a gratuity'. Holloway's body was then put on display at Brighton Town Hall (where 'many thousands' of people turned up to see it) before being sent to the county hospital for dissection.

One imagines that public executioners must become battle-hardened, but James 'Jemmy' Botting, who died in Brighton on 1 October 1837, was one who discovered that he had a softer side. In his last years, bedridden by strokes, he was oppressed by sleeping and waking visions of the people he had seen out of this life. They would pass slowly before him, wearing white nightcaps, their heads on one side. After his death his landlord reported that 'the deceased met his end like a Christian person, although he sometimes was troubled with fancies about the offices he had performed'.

The last public execution at Horsham took place on 6 April 1844. John Lawrence had killed Brighton's police superintendent, Henry Solomon, with a poker. Those attending public hangings could buy dreadful verses by the so-called Catnach writers, and this unseemly practice continued even after there was no physical spectacle to enjoy. In 1866, for instance, when John William Leigh was about to hang for shooting his wife's sister in Brighton, the following ditty (with many more verses) was on offer:

> With a six-barrelled revolver he went on Thursday night
> To the Jolly Fisherman in Market Street to take away the life
> Of the landlady Mrs Harton – he was by Satan led –
> Where her husband, Mr Harton, had been ten months ill in bed …

Solomon was not the only senior police officer to die in the course of duty. Years later, in 1912, Inspector Arthur Walls was shot by a burglar in Eastbourne. John Williams was found guilty of the murder and hanged at Lewes on 28 January 1914.

Most murders are committed by men, so that killings by women seem even more odious. The feeling intensifies in the case of Mary Ann Geering (née Plumb), despite the fact that she did have a fairly rough start in life. The daughter of agricultural labourers in Westfield, near Hastings, she went into domestic service and became pregnant by a farmhand while still in her teens. She was forced to marry him, and they set up home in Guestling,

110 *The funeral of Inspector Walls at Eastbourne, 1912. The procession is passing along Grove Road on its way to Ocklynge cemetery.*

where they had eight children during a 30-year marriage characterised by poverty, frustration and anger. Deciding that she had had enough, she poisoned her husband with arsenic and successfully claimed sickness and death benefits from the Guestling Friendly Society. It must have seemed very easy. She next poisoned her 21-year-old son and then his 26-year-old brother. She had begun the same treatment on her 18-year-old son when a local doctor became suspicious. The three bodies were exhumed, and the game was up. Geering was hanged outside the old Lewes gaol on 21 August 1849 before a crowd of four thousand.

Within three years Sarah Ann French of Chiddingly followed her to the gallows at Lewes for perpetrating the notorious 'onion pie murder' and became the last woman in Sussex to face public execution. Her husband was a labourer at Sheen Farm. On Christmas Eve 1851 he complained of stomach pains, and by early January he was dead. Although the coroner had recorded a verdict of accidental death, the rumours running round the *Six Bells* pub in the village led to French's body being exhumed and temporarily placed in the belfry of the parish church nearby. A fresh coroner's jury then

met at the *Six Bells* and pieced together what had happened. French was sent for trial at Lewes Assizes.

William Funnel, a friend of the dead man, told the court that on Christmas Eve French had been in high spirits and looking forward to a rarity in his home, an onion pie. When the two arrived at French's home near the *Gun Inn* a young man named James Hickman was already there, and Funnel noticed a certain coolness between him and French. French nevertheless sat down to the meal he had been looking forward to with such relish. The jury then heard that Mrs French had previously visited Mrs Crowhurst, the wife of a farrier at Horsebridge, and asked for two pennyworth of arsenic 'because I'm just over-run with mice'.

It was a straightforward enough story: French had murdered her husband because she would rather be with Hickman. Desperate to escape the noose, she now attempted to blame Hickman for the murder, but the jury had no doubt where the guilt lay. Some four thousand spectators turned up for the hanging, although one eye-witness perhaps spoke for a number of them: 'On hundreds of faces in the crowd – and of youthful ones – we could only observe the smile of levity, or the callous laughter of recklessness. As for the moral lesson, there was none; indeed, we are confident that it only requires the repetition of such scenes to render the effects of such an execution not only totally inoperative for good, but directly effective for evil.'

And yet, as we observe today outside any court in which high profile murder cases are being tried, many people continue to find such dramas irresistible. This ghoulishness was evident in the second of two 1920s murders at the Crumbles, the then desolate area of shingle between Eastbourne and Pevensey which has since been largely covered by the Sovereign Harbour. The cases were unrelated, but both victims, coincidentally, were shorthand typists. In 1920, 17-year-old Irene Munro, on holiday in Eastbourne from London, was killed by two local men, Jack Field and William Gray. They were hanged for the murder without ever disclosing their motive. In 1924 Patrick Mahon killed his pregnant lover, Emily Kaye, and then burned her head and limbs. The horror of this caught the public imagination. Entrepreneurs took over the lease of the bungalow in which the crime had been committed and gave guided tours at a shilling a time. Local protest prevented this briefly, but the tours soon started again with the price up to 1s. 2d. Postcards of 'the murder bungalow' sold in large numbers, with some scenes showing spectators straining for a better view.

Two Brighton trunk murders within the space of a few weeks during 1934 might seem too much of a coincidence, but so it seems to have been.

111 *Getting a closer look at 'the murder bungalow' on the Crumbles.*

The first came to light on 17 June, when a woman's torso was found in a trunk at the station's lost luggage office. The legs were discovered at King's Cross the folowing day, but the head and arms were never recovered and the identity of the pregnant young woman was never revealed. Sir Herbert Spilbury, the famous pathologist, played Sherlock Holmes: the victim was 25-30 years of age, about 5 feet 2 inches in height and weighed probably 8 stone 7lb; since she had taken great care over her appearance he judged that she had come from a middle-class background; and the fact that her hands, nails and feet were well kept led him to believe she had not engaged in any dirty or strenuous work. A former medium offered her services, telling the police that they should look for a man with dark brown hair, aged about 36, living in either London or Southampton and with the initials G.A. or G.H. She thought he might be a George Henricson or Robinson. They drew a blank, and nobody was ever charged.

Four weeks later, on 15 July, police looking for the missing head and arms found the complete body of 42-year-old professional dancer-cum-prostitute Violette Kaye in a trunk at 52 Kemp Street. She had been killed by a blow to the head. Her pimp was Tony Mancini, a man 16 years her junior, whose real name was Cecil England but who used several aliases. He had been questioned by police about the first trunk murder because Kaye had been reported missing, but he had convinced them the body was of a woman too young to be his mistress. Now he was himself missing.

I'll fight the murder smears all the way

Exclusive story by Carolyn Robertson

TONI MANCINI, who stood trial for one of Brighton's ˙ notorious trunk murders, told the Argus today: "I'm innocent."

A shocked and ailing Mancini — now being linked with the first gruesome trunk killing 52 years ago — said: "I'll fight the lies until the day I die."

I found Mancini, a frail 78-year-old invalid, living under an assumed name at a South London address. Until now police had thought he could be dead.

Discovery of his whereabouts and the news that police have reopened the case shocked the former Brighton waiter, night club owner and petty criminal.

Sitting in an armchair in the living room of his flat, Mancini said: "I'll go to the end of the earth and bring the whole of them down with me if they try to connect me with that murder."

The Brighton Trunk Murder shot to national headlines when the rotting torso of a woman was found in a trunk at Brighton station.

Her legs were later discovered squashed into a suitcase at King's Cross station. Her

Toni Mancini in the 1930s

arms and head were never found and her identity and killer remained a mystery.

The 1934 case was soon followed by the discovery of another corpse. Detectives identified it as blonde dancer and prostitute Violette Kaye, 42, whose decomposing body was found in a trunk in a flat rented by Mancini in Kemp Street, Brighton.

At the trial it was claimed any one of Kaye's clients could have killed her and Mancini was found not guilty.

But for Mancini the episode has refused to die.

Ten years ago newspaper reports claimed he had confessed to accidentally killing Kaye during a heated argument, but he could not be retried.

And now police have reopened the first Brighton Trunk Murder investigation after discovering new information from a West Country gardener.

112 *The Brighton trunk murder revisited.*

Various details came quickly to light. Violette had last been seen, looking distressed, on 10 May. The following day her sister had received a telegram, in capital letters and allegedly from Violette, saying GONE ABROAD. GOOD JOB. SAIL SUNDAY. WILL WRITE. VI. Mancini had told people that he had left her because of her nagging. He allegedly told one friend that it was no good hitting women with your fists because you only hurt yourself: 'You should hit them with a hammer the same as I did, and slosh her up.' A burned hammer head was found in the house he and Violette had previously shared at 44 Park Crescent.

Macini was arrested on 17 July at Blackheath, on the London-Maidstone road, and appeared before Lewes Winter Assizes on 10 December 1934. The evidence began to pile up against him, but he was brilliantly defended by Norman Birkett, who managed to cast some doubt on the theory that the hammer had been the cause of death; perhaps Violette, who drank and took drugs, had fallen and hit her head. Mancini admitted forging the telegram. He claimed he had found Violette dead on his bed at Park Crescent and that, in a panic, he had wheeled her in a basket to Kemp Street. He believed she had been killed by a client.

Birkett (who privately regarded Mancini as 'a despicable and worthless creature') addressed the jury for an hour, concluding, 'Now that the whole of the matter is before you I think I am entitled to claim for this man a verdict of not guilty, and, members of the jury, in returning that verdict, you will have vindicated a principle of law, that people are not tried by newspapers, not tried by rumour, but tried by juries called to do justice and to decide upon the evidence. I've asked you for, I appeal to you for, and I claim from you a verdict of not guilty. Stand firm!'

After two-and-a-half hours of deliberation the jury found Mancini not guilty, and there – whatever the questions that remained – matters might have rested. Some 42 years later, however, on 28 November 1976, Mancini confessed to a *News of the World* reporter that he had, in fact, committed the murder. And yet another ten years later to the day (the newspaper had obviously kept a good diary) the *Argus* in Brighton ran a story headlined 'I'll

fight the murder smears all the way'. An elderly Mancini had been tracked down and was once again protesting his innocence. Meanwhile, the police said that they had reopened the file after discovering new information from a West Country gardener . . . It was, if nothing else, entertaining.

One of the greatest murder mysteries of recent times was the disappearance of the dashing Lord Lucan, old Etonian and Coldstream guardsman, after apparently killing his children's nanny, having mistaken her for his wife. A reckless gambler, he had separated from his wife and, in an expensive High Court case, lost custody of their three children. The killing happened in London, but Lucan then made a dash to Sussex, driving his dark blue Ford Corsair at speed into Uckfield and, just before midnight on 7 November 1974, knocking on the door of his old friends Ian and Susan Maxwell Scott. He was dishevelled and his trousers were bloodstained. He told Mrs Maxwell Scott (her husband was away) that he had interrupted an intruder in the family home and had fled for fear he would be blamed. She gave him four Valium tablets and, at about 1.15, he drove off into the night and was never seen again.

What happened to Lord Lucan? The Ford Corsair was discovered abandoned in Norman Road, Newhaven. Had he taken the ferry to Dieppe? Did a friend smuggle him out of the country? Perhaps we shall never know.

Our final crime is one that made the huge impact it intended and killed five people, too, but failed in its main objective, the murder of Prime Minister Margaret Thatcher. The huge IRA bomb that demolished a section of the *Grand Hotel* in Brighton in the early hours of 12 October 1984 was timed to coincide with the Conservative Party conference. The hotel was eventually revamped in its original style, but with additions which improved its star rating. It was reopened on 28 August 1986 – by Margaret Thatcher, of course.

113 *The* Grand Hotel, *Brighton, after the IRA bomb intended for Margaret Thatcher and her cabinet.*

Eight

THE AWKWARD SQUAD

The unofficial Sussex motto is 'Wunt be druv', and this chapter looks at a streak of obstinacy which may occasionally stray the wrong side of the law, but is far removed from what most of us would regard as crime. Jack Cade's rebellion in 1450, during which the ordinary people decided that they had had enough of unfair taxation and general misrule by the authorities, was the attitude taken to its riotous extreme: it almost ended in the overthrow of Henry VI's government. The Swing Riots of 1830 – the so-called 'mobbing winter' – was a similar furious protest against low wages and high prices, and it similarly terrified those who held the power.

Should we include illegal boxing bouts in this bloody-minded category? They fit, because they were a declaration of the public's determination to enjoy themselves as they chose – and let the police catch them if they could. There were many of these surreptitious contests in the 19th century. On 8 October 1805, for instance, a man who fought under the name of the 'Game Chicken', and who trained in the Lewes area, fixed a fight with a youngster named John Gully. They were about to get under way somewhere between East Dean and Jevington when the police arrived, so they set off for Willingdon, where a pursuing magistrate called Harben called in a troop of Light Dragoons. The two men promised to travel to Kent, but in fact ended up in Hailsham, which was outside Harben's jurisdiction. The 'Game Chicken' won in the 59th round after an hour and a quarter.

114 *The memorial to Jack Cade in Cade Street, near Heathfield.*

On 4 April 1823, Daniel Watts, a bricklayer, and James Smith, a sawyer, chose to fight at Ovingdean because it was just outside the Brighton borough boundary and the constables would be powerless to stop it. This was a famous prize fight. The ring was roped out, and the bout began just before four in the afternoon. After more than an hour Smith was knocked out and never regained consciousness: he died the next morning. Watts was charged with manslaughter, but he died of his own injuries before he could be brought to trial.

The very last prize-fight of this kind took place at Wadhurst on 17 April 1860. Three years earlier the English stylist Tom Sayers had been badly injured in a fight with an American giant, John Heenan, who had at one stage attempted to throttle him. Now Heenan was challenged by Tom King to settle the question of English or American superiority. The fight took place on the roaside near Wadhurst Common. King's youth and boxing ability eventually won the day, but the fight went on for all of 36 rounds, arousing public indignation and disgust. Prize-fighting had to throw in the towel.

Strike action is an industrial bolshiness not so much in favour as it once was. It had a glorious fling, both locally and nationally, with the General Strike of early May 1926, triggered by a proposed pay cut for coal miners. Support for the strike was very strong in Brighton – stronger, indeed, than anywhere else in the south of England. On the first day, Tuesday 4 May, public transport came to a halt. The railway engineering works was completely closed down, and there were no newspapers. With the threat of violence in the air, special reserve constables were sworn in and the regulars were ordered to sleep at their posts.

The trams became the focal point of the crisis. The council's tramways committee suggested that volunteer labour might be used to get them running again, provoking some 2,000 strikers to march towards the Town Hall. Although they were diverted, a smaller crowd of around 200 turned up at the Town Hall the following day. What happened next further inflamed the protesters. A woman driver deliberately accelerated her car towards them, injuring several people, and police with truncheons removed strike supporters from the vehicle, allowing her to escape.

On Tuesday 11 May the protests came to a head in the so-called Battle of Lewes Road (a reference, of course, to the Battle of Lewes of 1215). Some 4,000 strikers massed outside the tram depot in Lewes Road in the belief that middle-class volunteers, including students, were about to drive the vehicles out – although in reality they were at the depot in order to be trained for a later occasion. The chief constable, Charles Griffin, ordered the crowd to disperse and was ignored. He had with him 300 officers on foot and 50 mounted specials (known as the Black and Tans) carrying ash staves. They began to advance.

A vicious fight now took place. The specials charged at the crowd, lashing out with their batons, and some of the strikers hit back. The crowd, including many children, retreated in chaos. Seventeen strikers were arrested by the police and marched through Brighton to the police station at the Town Hall. Two people were seriously injured, and many more were

115 *The mounted specials who took part in the Battle of Lewes Road are seen here in Brighton Place, close to the police station in the Town Hall.*

hurt. In the bitter atmosphere that followed there were further disturbances and arrests.

Those who came before the court were given heavy fines and sentences of up to six months' hard labour. At noon the same day the General Strike was called off, and the trams were running again within hours. The police officers involved were given certificates by the council, with three days' extra leave granted to the regulars. There was a victory parade of mounted specials outside the Floral Hall, and a celebration dinner at which 'Ice bricks à la Lewes Road' were on the menu. Some of the strikers, on the other hand, were never reinstated in their jobs, and resentment of police heavy-handedness lingers in Brighton even to this day.

There is, it must be admitted, a world of difference between people fighting for their, or other people's, livelihoods and young people fighting for pleasure. The 'Mods and Rockers' violence that came to our seafronts in 1964, and continued intermittently thereafter, was extremely unpleasant for any innocent victims caught up in it. The rockers were greasy-haired, leather-clad motorbike riders, while the mods favoured short haircuts, smart clothes and motor scooters. Trouble erupted at Brighton at Whitsun 1964, and subsequent bank holidays were threatened by further outbreaks at coastal resorts all over the

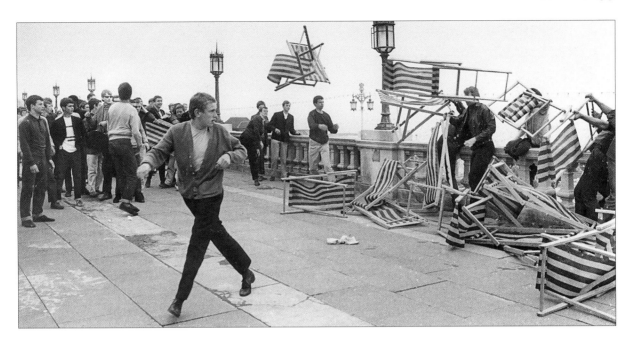

country, but especially those within reach of 'swinging London'. Under the headline 'High Noon Flashpoint on Brighton seafront', the *Argus* reported in 1969 that 'Mods and rockers hit Brighton yesterday. Bank Holiday crowds fled the beaches as rival mobs of youngsters fought with stones and bottles. Seven were arrested. Two were taken to hospital. And extra police drafted into the area stood on patrol until nightfall.'

The courts imposed penalties ranging from spells at detention centres to prison sentences, and Brighton Council even considered the idea of setting up labour camps – with 'periods of enforced work' – for hooligans. But it was, as some tiresome adults must have said at the time, just a phase.

It's hardly surprising that most of the incidents in this chapter involve Brighton. The place is sometimes called London-by-the-Sea, and its street-wise, cock-a-snook side is legendary. If there's a chance of a protest there is usually a group that will take it. This speak-our-minds contingent was swelled by the opening of the University of Sussex in the 1960s, bringing an influx of anti-authoritarian youngsters to the town.

116 *Mods and Rockers fighting on the seafront at Brighton, Whitsun 1964.*

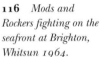

117 *Mods and Rockers at Hastings, August 1964. One of the police officers is from Brighton, a reminder that the size of the mobs often necessitated cooperation between local forces.*

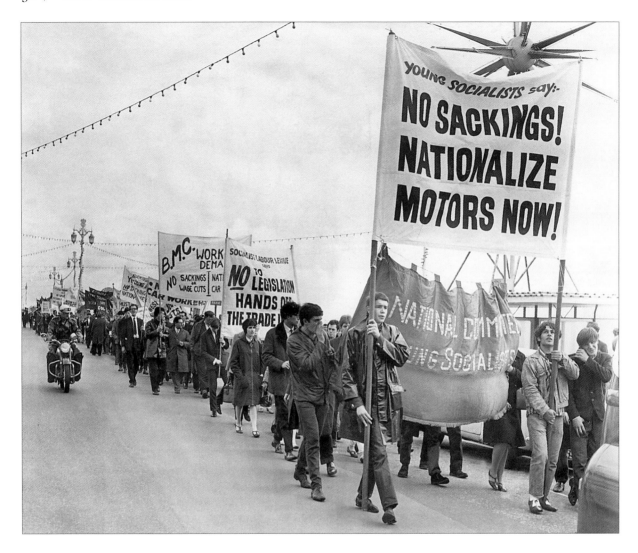

118 *Young Socialist march on Brighton seafront, October 1966. The occasion was the Labour Party conference. Confronted by a range of economic problems, the Wilson government was about to impose a wage freeze.*

No one who lived in Brighton during the mid-1970s will forget the squatting controversy. The number of empty properties in the town was seen as a scandal at a time when many were homeless, and there were many protests; the later leader of Brighton Council and now member of the Upper House, Lord Bassam, was (as plain Steve Bassam) one of those prepared to man the barricades. The siege of Terminus Road was among the more celebrated spats. A derelict council house had been occupied for a month by squatter Pat Flynn with his wife and four children. Mr Flynn, a 27-year-old artist, said they had nowhere else to live, but a judge ordered the family to leave and on Friday 31 May 1974 the bailiffs arrived to evict them. Demonstrators scuffled with police outside, while the Flynns' supporters, using a megaphone to publicise their cause, hurled flour, sand,

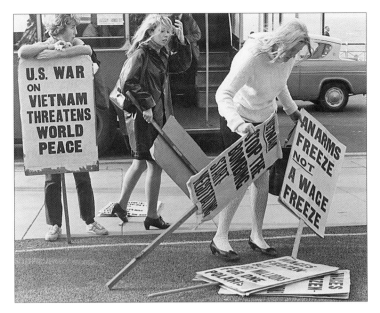

119 *A protestor having to make a hard choice between slogans, including the war in Vietnam.*

coffee and water from the windows. One of the demonstrators, 27-year-old teacher David Bell, had chained himself to the front door, and the bailiffs vainly tried to free him with bolt-cutters. After three attempts to get in they withdrew, although they did, of course, come back another day.

120 *The siege of Terminus Road, Brighton, with squatters making life difficult for the bailiffs.*

The threatened conversion of the Royal Spa in Queen's Park into a casino and restaurant was another *cause célèbre* during this period. The locals wondered why not turn it into a nursery school? The building, standing in the south-western corner of the park, had been opened as an artificial spa in 1825, using mineral waters chemically identical to those of many European spas. The pump room had closed in the 1850s, but Hooper Struve Ltd had manufactured bottled mineral waters there until 1965. By the mid-1970s it belong to the local council, a worthy opponent. As so often, the protestors showed imagination, not simply marching and agitating, but digging up the ground to make an allotment, and starting a street newspaper called *QueenSpark* that was sold from door to door. Although part of the building was pulled down, the rest was restored – and a nursery school opened in it during 1977. *QueenSpark*, meanwhile, developed into an established publishing group, specialising in local oral history.

The apparent invincibility of Prime Minister Margaret Thatcher was given the lie when her hated poll tax (or community charge, as it was officially

121 *Digging up the Spa grounds in Queen's Park, Brighton, 1975.*

called) provoked what one might call a national uprising. The idea of taxing people an equal amount rather than proportionately according to income was regarded as grossly unfair, and many people flatly refused to pay. Brighton saw a mass demonstration on 14 April 1990. A Highland piper, Dave Hodge, led 200 campaigners from the Town Hall to the Level. Others marched from Moulsecoomb, Whitehawk and Queen's Park, vowing to burn their poll tax forms as a show of defiance. The *Argus* reported that there were some 800 people at the rally.

> Organisers stressed the event would be peaceful, with clowns and entertainers instead of riots and violent scenes. Rebel council leader Jean Calder said trade unionists would call on the crowd to boycott the poll tax. She said: 'The thrust of this meeting is to build a mass campaign of civil disobedience. I think the majority of people here would be non-taxpayers, but there will also be people who simply cannot afford to pay.'
>
> The march comes as harassed council poll tax staff say they are working in fear of attack. Brighton's NALGO branch organising officer Stuart Neate said they were worried about the risk of violence to members. He said: 'The poll tax is very unpopular and this is making collecting difficult. It is still too early to say how people are going to react, but we are aware our members could face abuse.'

Country walking may be a relatively gentle business, but ramblers have a long history of protesting about rights of way. In March 2003 a group of them were celebrating victory after a 13-year legal tussle over a footpath

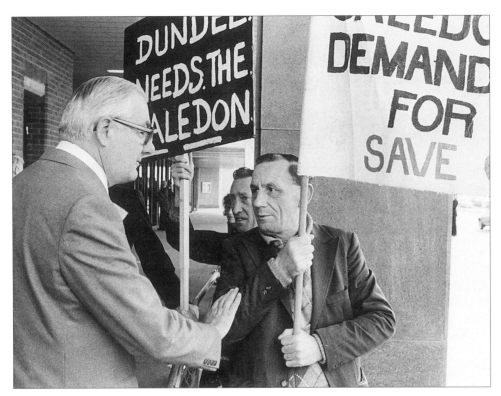

122 *The opening of a new building is always a good occasion for those who have a point to put across, and James Callaghan can hardly have been surprised to find himself facing placards when, as Prime Minister, he opened the Brighton Centre in September 1977. He was, as ever, unflappable.*

on the High Cross Estate at Framfield, near Uckfield. What gave the battle extra spice was the fact that the land was owned by a company connected to the millionaire landlord, and now convicted killer, Nicholas Hoogstraten. From the path could be seen Hamilton Place, the huge mansion being created by Hoogstraten to house his art collection and, eventually, his body.

123 *Poll tax protestors at the Level in Brighton, April 1990.*

The dispute began in 1989 when rambler Jack Dunn from Buxted noticed that a barn had been erected on the path. Over the years the obstacles grew: a gate, barbed wire, refrigeration units. Magistrates found the company guilty of illegally blocking the path and imposed fines, but to no avail. East Sussex County Council, which manages the land, issued a diversion order so that the footpath would go around the obstruction, but Kate Ashbrook, a

125 *Victory: ramblers trample a Keep Out sign.*

124 *Nicholas Hoogstraten's extravagant mausoleum, Hamilton Place, near Uckfield.*

rambler for whom the campaign had become a personal crusade, took the council to court, claiming that, in taking the easy way out, it was failing to do its job. The council lost, incurring £26,000 in its own legal fees and £50,315 in costs to the indomitable Mrs Ashbrook.

On 4 March 2003 the *Argus* reported: 'After seven court cases and more than £150,000 in fines and court charges, the land is finally clear and, as of yesterday, open to walkers again.'

It does sometimes pay to be awkward.

Nine
CELEBRATIONS
AND
SPECIAL OCCASIONS

Many were the festivals of Old Sussex, which marked the seasons and, no doubt, helped bring some relief to what must have seemed, for the masses, chiefly a life of toil and care. Some now seem bizarre. On St Andrew's Day (30 November) people would go 'andring' – piling into the woods with sticks and guns to kill squirrels. The Rev. W.D. Parish of Selmeston, author of the *Dictionary of the Sussex Dialect*, said the custom had been kept up until the 1820s, later succumbing to enclosures and the stricter preservation of game.

When the opportunity arose, new celebrations would be added to the calendar. In Brighton 29 May was 'pinch-bum day'. This was the birthday of Charles II, and also the day on which he returned to claim the throne in 1660. Elsewhere in Sussex it was Oak Apple Day: children would wear an oak apple or oak leaf, the penalty for not 'sporting their oak' being a slash on the legs with a stinging nettle. The Brighton version is said to derive from the time when Col Carless had to keep pinching the King on that meaty area

126 *Garland Day was revived in Lewes by William Verrall in 1874. This is a photograph of the 1883 event.*

127 *A publicity photograph for the 1980 Stanmer Country Fayre – a tradition being successfully invented.*

128 *The 1982 Fayre, from the church.*

HASTINGS AND ST LEONARDS OBSERVER. SATURDAY.
FOUR GOLDEN WEDDINGS IN ONE FAMILY.

GUY FAWKES, HASTINGS

129 *A reminder that celebrations are often personal rather than public. This page from the* Hastings and St Leonards Observer *in December 1923 records a remarkable event. In those days the longevity of the couples was the chief surprise; today we would marvel at the longevity of the marriages.*

to prevent him falling asleep, and so out of the tree, after the Battle of Worcester.

 In modern times, when so many customs have long withered on the vine, there have been attempts to revive former traditions or create new ones with a properly ancient feel. This enterprise is not necessarily doomed to failure. Thomas Hardy remarked that in his day you could always differentiate an event carried on since time immemorial from a recent revival: if it was a revival the people taking part in it were enjoying themselves! Garland Day in Lewes was just such a revival, and it seems to have worked, since there is still a cheerful procession through the town each year, with the children taking great pains to create colourful swatches of flowers to carry or wear on their heads. More recently Charles Yeates and a group of friends belonging to Stanmer Preservation Society decided to create a 'Georgian-type fayre', with people dressing up in period fashion to man stalls in the village street, selling home-made produce and crafts. This was less a genuine revival than a new event with ancestral echoes, but it certainly worked. The first, a one-day affair, was in 1976, and it was so successful that two-day events were held in 1978, 1980 and 1982. 'It just seemed to evolve of its own accord,' remembers Betty Driver.

130 *An effigy of Guy Fawkes at Hastings, 1910.*

131 *Waterloo Bonfire Society on the march in the annual Lewes procession. The town has five societies, all proudly individual and competitive, and the 5 November event is the best in England.*

The event grew bigger and bigger, with visitors coming from all over the country and from abroad. It created a wonderful carefree atmosphere. Money was given to Stanmer Church, to cancer research, towards a kidney machine and to the Royal Alexandra Children's Hospital in Brighton.

Unhappily the fair became a victim of is own success – too large for a small community to handle without changing its character altogether. Will someone revive it one day?

Some traditions which we are tempted to think are ancient have taken their shape only in relatively recent times. Although the riot of benign misrule that is Lewes Bonfire Night makes a great thing of the Protestant martyrs, this aspect of it dates only from the mid-19th century when the Anglican church felt at threat from the growth of Roman Catholicism. This in no way detracts from the event, which is, in any case, mercifully free of genuine religious rancour: any tradition worth its salt will, after all, change with the people who use it.

132 *Circus elephants outside the White Rock, Hastings.*

133 *Water fête on the Pells at Lewes c.1897.*

134 *Sangers Circus parades its camels along Lewes High Street, 1898.*

135 *The formal opening of Queen's Park, on 10 August 1892. Established in the 1820s, the pleasure garden was presented to Brighton Corporation in 1891.*

136 *The opening of Volk's Railway on 4 August 1883. Magnus Volk stands on the footplate to the left of the carriage. Born in 1851, he has been called 'the English Edison' because of the wide range of his inventions, but his lasting monument is the electric railway which still runs along Brighton seafront.*

137 *The centenary of Volk's Railway. At the wheel, with hand raised, is 83-year-old Conrad Volk, the founder's youngest son.*

138 *Unveiling the Clock Tower in Brighton, 20 January 1888. 'The only permanent memorial that Brighton has of Her Majesty's Jubilee,' wrote the Brighton Gazette, 'was unveiled on Thursday – Coronation Day – in the presence of several thousand spectators.' Its chief feature was the so-called time ball, designed by Magnus Volk and controlled by land-line from Greenwich Observatory, which rose hydraulically up the mast and fell on the hour. The clock tower has recently been restored.*

139 *The first Brighton speed trials on Madeira Drive, July 1905. The photograph shows Clifford Earp, who won the Daily Mail Challenge Cup, on the starting line with J.E. Hutton. After a great deal of controversy the roadway was given a full tarmac surface for an event which was allowed as an experiment. Among those seeking to drive fastest over a fixed mile were C.S. Rolls (of Rolls-Royce), T. Schneider (founder of the Schneider Trophy races), J.T.C. Brabazon and A. Lee-Guinness. The highest speed was 90.2mph, achieved in a 90hp Napier by S.F. Edge, who lived at Westmeston. Dorothy Levitt came fourth and gave the best performance in a British car. The noise and fumes made the event unpopular with neighbouring residents and hotel owners, and it was not repeated until the 1920s.*

140 *Motoring events didn't need to be ear-blasting affairs. Here we see a motor gymkhana at Hastings. Miss de W. Harries and her Renault car are taking part in the obstacle race.*

141 *In 1906 the First World War was still a long way off, but* entente cordiale *events were arranged to cement ties between England and France. Here we see a tram procession in Hastings.*

142 *It's 9 May 1907 and a similar event takes place in Brighton: the Comité du Commerce visits the Royal Pavilion.*

143 *The finish of a boat race at Cliffe Bridge, Lewes.*

144 & 145 *Two views of Empire Day in Lewes, 1908 and 1911. The event coincided with the late Queen Victoria's birthday and replaced the traditional May Day in many schools' calendars. Tony Wales has written that 'it appeared to be welcomed by authority, who had to some extent looked upon May Day as the remains of a pagan festival'. Children danced round the maypole with flowers in their hair, but there was patriotic flag-waving, too.*

146 *The proclamation of King George V in Hastings, 1910.*

147 *Christening a new fishing boat on the Stade, Hastings, 26 April 1910. The 28ft EVG (RX 152) was the biggest of the last generation of sailing boats to be built without an engine. A crowd of several hundred watched her launched by the wife of the local Conservative MP, Arthur du Cros. The boat was built for Edward 'Woolly' Tassell, the letters EVG apparently being initials of members of his family. She was sunk by a mine in Rye Bay in March 1943.*

148 *Proclamation of George V in Terminus Road, Eastbourne, June 1910.*

In days gone by there were wonderful processions through the streets whenever a circus came to town, whereas today there will usually only be a small 'photo opportunity' for the local newspaper. Not only was there was more room on the roads then, but the proprietors had some big beasts to show off. Many of us will applaud the disappearance of wild animals from the sawdust ring while having vivid childhod memories of snarling tigers and of intelligent elephants keen to earn their buns. Television gives us a broader and a better picture, but it isn't the same thing.

Not that we have lost our ability to have a good time. There may be fewer carnivals than there once were (although many a town or village still supports one), and an occasion such as Empire Day has, for obvious reasons, long since faded from the national consciousness, but we remain quick to seize the opportunity offered by a centenary or the opening of a new facility. With our long Sussex coastline and our enviable hours of sunshine, moreover, we are in a good position to enjoy a wide range of outdoor activities during the summer months – and some of them have been featured here.

149 *Brighton Carnival, 1923, the procession passing along Madeira Drive, with thousands of people looking down from the upper levels. The town's very first carnival had been held the previous year.*

150 *Palace Pier Carnival, August 1936. Ideal shapes have changed over the years – as have microphones.*

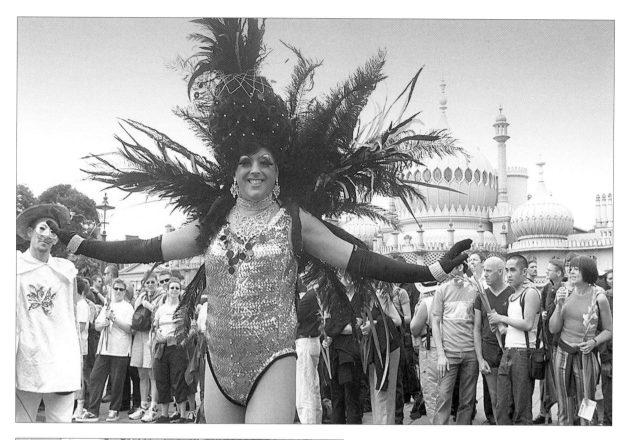

151 *Gay Pride march, Brighton. The town is the gay capital of England, and the Pride march is now an established fixture in the calendar.*

152 *London to Brighton bike ride. Not a race, this amazing event attracts some 27,000 official entrants each June, plus quite a few more who haven't got round to registering. The finish, of course, is at Madeira Drive.*

153 & 154 *Fatboy Slim concert, Brighton beach, July 2002. Local DJ Norman Cook (alias Fatboy Slim) was taken aback by the response to his beach party. So many people turned up that there was (largely good-natured) chaos, and the clear-up operation cost many thousands of pounds. Cook himself paid for much of this – and vowed never to repeat the exercise.*

The most sensational of recent events was the Fatboy Slim concert on the beach in July 2002. The *Guardian* reported the event the following Monday:

> One man died and at least 100 people were injured in Brighton after more than 200,000 people attended a free concert on the beach, overwhelming emergency services and bringing chaos to the seafront. About 60,000 people were expected to attend Saturday evening's event, organised by Norman Cook, aka Fatboy Slim, but the combination of glorious weather and the DJ's popularity drew almost four times that number.

The *Argus* reported a spokesman for the Royal Sussex County Hospital as saying, 'We were a hair's breadth away from declaring a major incident.' An army of cleaners had begun clearing more than 100 tonnes of rubbish, and a post-mortem was being carried out by police and council bosses who accepted that the concert had spiralled out of control.

'As the city woke up to a collective hangover yesterday,' the paper said, 'emergency services united, saying "Never again".'

Watch this space! …

Ten

MISCELLANEOUS

Inevitably, in compiling a book of this kind, there are events which obstinately refuse to fall into a convenient category. This chapter therefore gathers together a few disparate events of greater or lesser importance as a kind of postscript.

One which demands to be mentioned for its national implications is the flight of the future Charles II across Sussex in what came to be called The Great Escape. At the Battle of Worcester Cromwell had crushed a Scottish attempt to restore a Stuart to the throne of England, and Charles – a huge reward on his head – fled south in disguise. With the sympathetic Col George Gounter as his companion, he entered West Sussex from Hampshire and travelled east until he reached Brighton, where he spent the night at an inn in West Street. The following morning he was taken to safety in France by Nicholas Tettersell, captain of the coal brig *Surprise*. Tettersell, who later bought the *Ship Inn* on the seafront, is buried in the churchyard of St Nicholas.

A less important, but sensational, *faked* East Sussex event was the discovery of Piltdown Man in 1912. At the time it was believed this was the 'missing link' between apes and humans. On 16 September Arthur Smith Woodward made the first announcement of the find, at a meeting of the British Association in Birmingham. When it became clear, a full 40 years later, that the remains were a forgery the suspicion fell on the clerk to Uckfield magistrates, Lewes solicitor Charles Dawson, and many people still point the finger at him. Probably we shall never know.

The coming of the trams to East Sussex early in the 20th century is well documented in old picture postcards, and I include a few here. As we have seen, Brighton first introduced them in 1901 and had completed its system by 1904. The Hastings service came in stages, but swiftly. Hastings and District Tramways Company started operating on 3 July 1905 with 65 open-top cars. The following year a separate section was working from St Leonard to Cooden, leaving a 'missing link' of some two miles along Marine Parade, St Leonards,

155 *Laying tramlines in
Lewes Road, Brighton, 1901.*

156 *Laying tramlines in
Hastings.*

a gap that was filled in 1907. The trams lasted until 15 May 1929, when they gave way to trolleybuses.

The trolleybuses themselves had a relatively short life. In Brighton they were first introduced in April 1939 and the last run was in June 1961, so it's not altogether surprising that the vehicle which launched the service was still on hand to make the final journey. They were clean, quiet and generally popular, although they had a habit of jumping off their wires so that conductors had to use long poles to reconnect them. What helped kill them off was the price of electricity. In 1942 the Brighton buses carried nearly 22 million passengers, with petrol rationing helping to keep cars off the road. By 1955 the cost of electricity made them as expensive to run as their petrol-driven counterparts, and that year the borough transport committee made a profit of just £161. Losses followed, and the end was in sight.

Building the Beachy Head lighthouse in 1902 was a considerable engineering feat. (It was a replacement for Belle Tout lighthouse on the cliffs west of Eastbourne, which had proved to be ill-sited because it was so often shrouded in mist, and was sold as a private house.) A 6ooft aerial

157 *The first tram running past the clock tower at Hastings, 1905.*

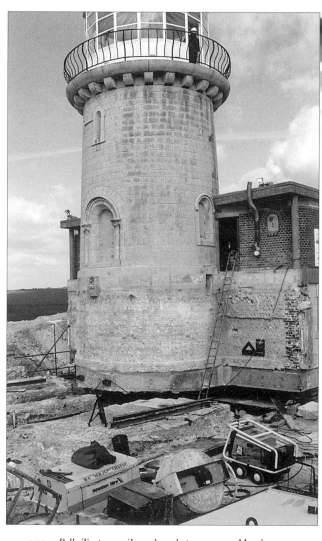

158 *The last trolleybuses in Brighton, on the Patcham and Fiveways routes, ran on 30 June 1961. As the sign says, this was both the first and the last of them.*

159 *Belle Tout on rails and ready to go on 22 March 1999.*

tramway was slung from the cliff to a platform on the beach, and this carried both men and equipment as the lighthouse took shape. Its foundations were embedded in 18ft of chalk, and more than 3,600 tons of Cornish granite were used in the building.

Belle Tout, meanwhile, was becoming ever more exposed by cliff erosion, and in 1999 it was only a few metres from the edge. The owner, Mark Roberts, decided it was time to move – or, rather, for the building itself to move. A media circus turned up to watch the amazing task of shunting a complete building 17 metres back from where it stood. First the floor of the

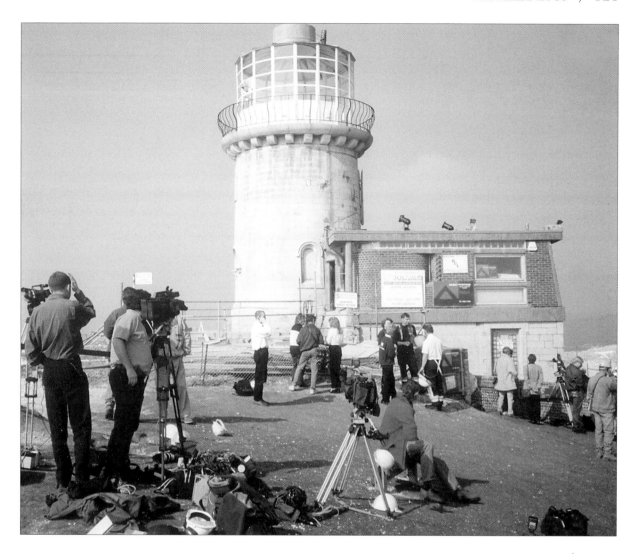

lower level was removed and the walls underpinned. Next a reinforced beam was gradually constructed under each load-bearing wall. Then sliding tracks were installed, to extend over the new lower storey further inland. Finally the building was jacked up and slowly, very slowly, moved to its new resting place. How long will it take for the lighthouse to be threatened again? Don't worry, say the engineers: forward planning has allowed for a further journey inland should it ever be necessary.

The idea of building an artificial harbour at Brighton goes back to at least the early 19th century, but it took garage proprietor Henry Cohen to come up with the scheme that eventually became Brighton Marina. The original cost was £9 million, but this was soon to seem a laughably optimistic figure. Discussions dragged on for a dozen years until, in May 1975, the

160 *Planning the moving of Belle Tout lighthouse, with several film crews standing by.*

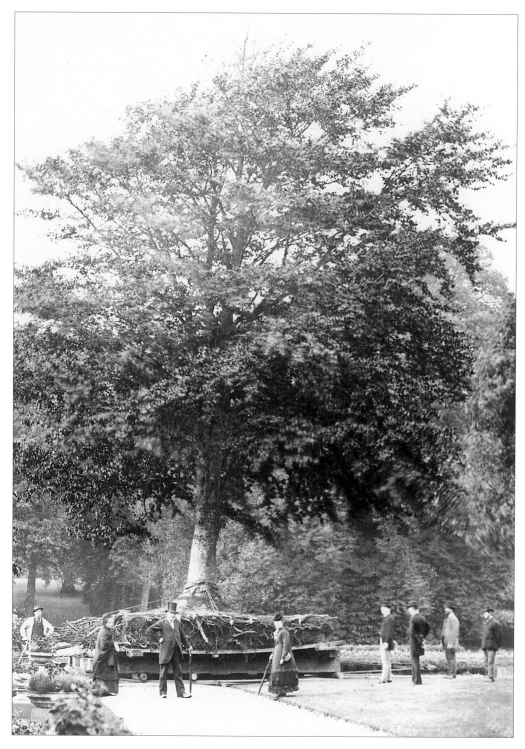

161 *As prodigious a task in its day as the moving of the Belle Tout lighthouse was the repositioning of this huge tree in the grounds of* Shelleys Hotel *in Lewes.*

Environment Secretary gave his approval for the Marina as long as the buildings inside it should not exceed half the cliff height. The wall of the inner harbour was finished in June 1975, and the breakwaters, enclosing 77 acres of sheltered water, were finished in the following year. The whole complex was opened by the Queen on 31 May 1979. Development has continued ever since, sometimes sporadically. There are shops, flats, moorings for 1,500 boats and berths for a small fishing fleet beyond the eastern pontoon.

Another massive development, and one as dogged by controversy as the Marina, was the Brighton bypass. Naturalists declared it was bad for wildlife, and those who enjoyed walking on the Downs said it would create a terrible scar with little compensating improvement in the traffic flow within the town itself. Brighton Council itself opposed it but went ahead on government recommendation. Six possible route were identified for public consultation,

162 An aerial view of Brighton Marina under construction by Taylor Woodrow c.1975, showing the tunnels and approach roads. In the centre of the site is the casting yard for the huge 600-ton caissons (110 in all) which would be lowered into position by an immense gantry crane and filled with a further 1,000 tons of concrete each to form the breakwaters.

163 *An early plan for a marina at Brighton, designed by William Henry Smith around 1841.*

164 *The opening of Brighton's nudist beach on 1 April 1980, the first on a major British beach. It was hardly in the most inviting position – or with the most comfortable material to sit on!*

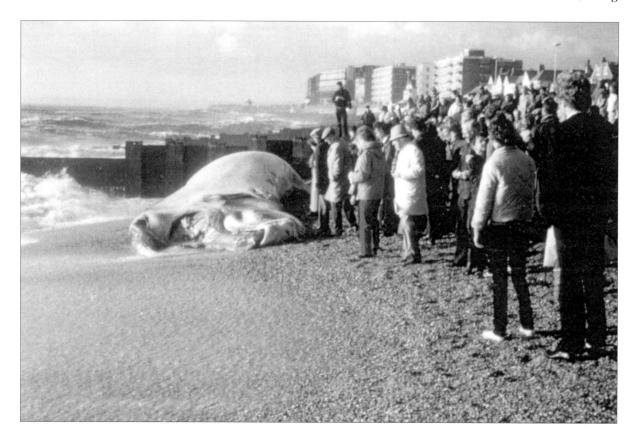

and in 1980 the Department of the Environment published a draft bypass route. The public inquiry into both the need for the road and its route lasted all of 97 days. The route of the new 8½-mile road claimed some 500 acres of land. The MP for Brighton Pavilion, Julian Amery, cut the first turf on 2 April 1989, and the bypass was opened in sections between 1991 and 1996.

165 *Onlookers get a close view of a whale washed up on the beach at Bexhill on 24 November 1984.*

We end with an engaging piece of nonsense in Brighton during 2002 – although not all the locals saw it that way. Some, indeed, thought the exercise a complete waste of money. Hoping to reach the shortlist of the European Capital of Culture, the city (a status it had recently been given) put huge body jewellery on some of its buildings.

166 *A bird's eye view of the Brighton bypass under construction, 7 September 1990.*

167 The last match at the Goldstone, 12 May 1999. Followers of Brighton & Hove Albion have suffered agonies over recent seasons, at one time being a match away from dropping out of the football league, and then having their ground snatched away from them almost overnight. The last match at the Goldstone ground was an emotional affair, Stuart Storer scoring the very last goal there in a 1-0 victory over Doncaster. With matches currently been played at the unsatisfactory Withdean stadium, most fans are now hoping for a permanent move to Falmer.

168 In the name of art: during 2002 Brighton made a bid to become European Capital of Culture, one of its bright ideas being the 'body piercing' of a number of buildings. Here is the former Holy Trinity church in Duke Street, now the Fabrica art gallery, with a spike seeming to run from one side of its tower to the other. Brighton's bid was unsuccessful.

Three huge tusks appeared on the portico of Brighton Museum; the neo-classical Town Hall sported ankle chains and baubles on its columns; the Fabrica art gallery, once Holy Trinity church, had an enormous spike apparently piercing its tower; and a local firm of accountants shook off the profession's boring image with a giant belly-button ring through its offices opposite the railway station.

This seemed fitting for a city whose chief executive, David Panter, himself wears earrings, but, sad to relate, it didn't sufficiently impress the judges. Never mind: it was undeniably an event.

INDEX

References which relate to illustrations are given in **bold**.